THE
LOST EXPLORER

A SHORT STORY
BY PATRICK McGRATH

IMAGES FROM A SHORT FILM
BY TIM WALKER

CINEMATOGRAPHY
BY ROBBIE RYAN

teNeues

The images in this book are stills from
THE LOST EXPLORER, a short film
by Tim Walker based on a short story
by Patrick McGrath.

The story appears in its original version.

BBC films presents
a Between the Eyes
and Rufus Production

THE LOST EXPLORER

ACTORS

Richard Bremmer
Olympia Campbell
Julia Davis
Dexter Fletcher
Jessica Hynes
Toby Stephens

CASTING DIRECTOR

Sasha Robertson

PRODUCTION & COSTUME DESIGN

Shona Heath

FILM EDITOR

Valerio Bonelli

DIRECTOR OF PHOTOGRAPHY

Robbie Ryan

EXECUTIVE PRODUCERS

Jack Arbuthnott
Ed Wethered
Gela Nash-Taylor

PRODUCED BY

Rory Aitken
Ben Pugh

WRITTEN BY

Kit Hesketh Harvey and Tim Walker

DIRECTED BY

Tim Walker

THE LOST EXPLORER

One fresh and gusty day in the damp autumn of her twelfth year Evelyn found a lost explorer in the garden of her parents' London home. He was lying in a small tent beneath a mosquito net so torn and gaping as to be quite inadequate, were there any mosquitoes for it to protect him from. His clothes were stained with sweat and blood, and a grizzled beard stubbled his emaciated face. On the folding stool beside the camp bed stood a flask, empty, a revolver, unloaded, two bullets, three matches, a small oil lamp, and a dirty, creased map of the upper reaches of the Congo. He was delirious with fever and occasionally gibbered about the pygmies. Evelyn thought he was wonderful.

And he thought she was wonderful, too. When the delirium had passed and he lay, pale, spent, and shivering, she loomed out of the fog that was his consciousness like a bright ministering angel.

'Agatha,' he whispered. 'I want a drink of water.' The angel vanished, and the explorer lay panting feebly in his tiny tent. In the deep, still place at the center of his frenzied mind a flame of hope was lit, for Agatha was here. What happened was this: the explorer had mistaken Evelyn for the nanny who'd nursed him through a childhood illness!

Evelyn returned to the tent with a cup of water. She folded back the ragged netting and helped the explorer onto an elbow. Much of the water spilled onto his bush jacket, but at length his parched lips smacked up their fill and he lay back, exhausted. Evelyn gazed down at him with benevolent compassion.

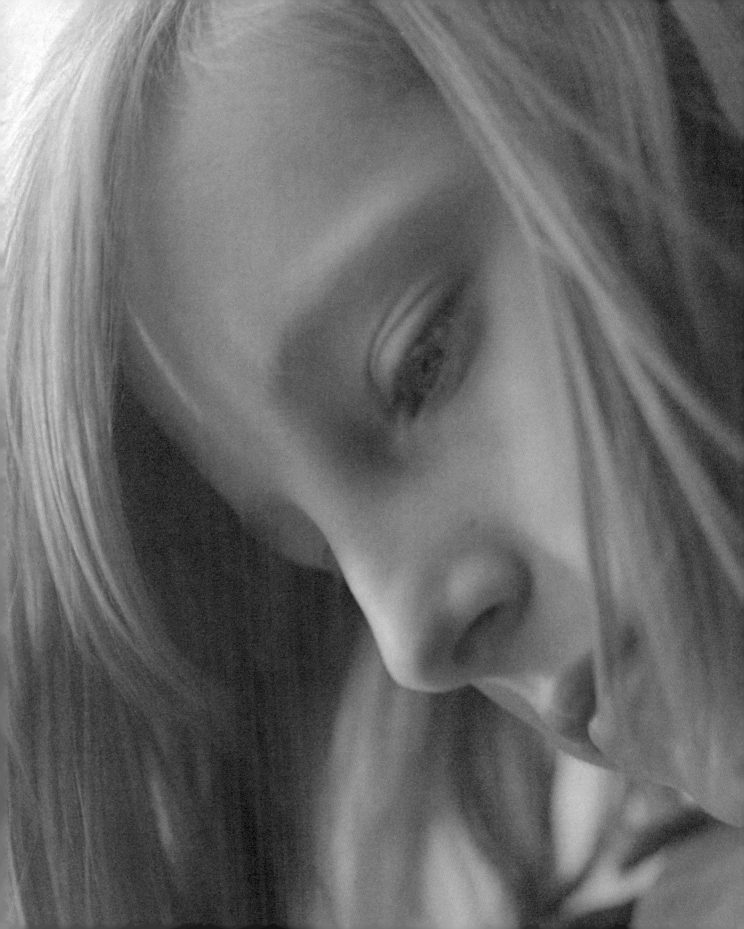

'Agatha,' he whispered, 'give me your hand.' She knelt on the ground beside the camp bed and took the explorer's clammy palm in her fingers. A ghost of a smile hovered at the cracked edges of the man's lips. 'Agatha,' he sighed; but then, seized suddenly with a fresh wave of panic, he started up from his bed. 'The pygmies, Agatha!' he shouted. 'I hear the pygmies!'

Evelyn remained calm. She laid her cool hand upon his fevered temples. The traffic of London murmured in the thoroughfares beyond. 'They're miles away,' she whispered. 'They don't know you're here.'

'They're coming!' he shouted, his head jerking from side to side and his red-rimmed eyes abulge. 'They're coming to eat us!'

'Nonsense,' breathed Evelyn, stroking that troubled brow. 'No one's going to eat us.'

The panic passed; a moment later the tension was visibly draining from the explorer's body. He sank back onto the camp bed. 'Agatha,' he said weakly, his hand still clutching hers. 'You're good.'

'Rest,' murmured Evelyn. 'Sleep. You're safe now. Sleep.'

When she was sure the explorer was sound asleep, Evelyn skipped up the garden to the house. A washing line was strung from a post at the top of the steps to a tree by the wall at the side of the house. To this line were pegged three white sheets, all flapping wildly in the wind. Dead leaves spun about the girl as she pattered gracefully up the steps from the garden. She opened the back door. Her mother and Mrs Guppy were bent over the oven with their backsides to her.

'Are you quite sure it's done, Mrs Guppy?' her mother was saying.

'It's had twenty-five minutes, Mrs Piker-Smith. It must be done.'

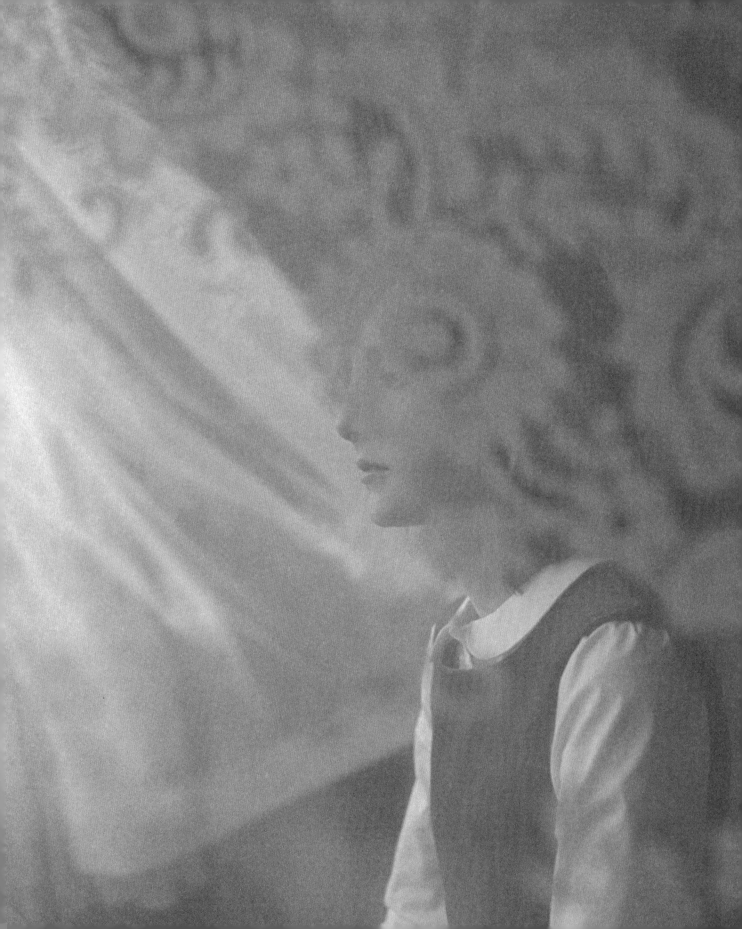

'Oh, I do hope so. Gerald is so fussy about his chop. Ah, there you are Evelyn. Run and wash your hands, dear, and we'll eat.'

Mrs Piker-Smith was a plump, tweedy woman, and she was commonly in the throes of mild anxiety. Ten minutes later she sat at the dining-room table gazing at her husband, Gerald, the eminent surgeon. He in turn was gazing at his chop. Evelyn had already started to eat, and paid no attention to either of them.

'Is it all right, dear?' said Mrs Piker-Smith. 'We gave it almost half-an-hour.' Her own knife and fork were poised at a shallow angle above her plate. A sudden gust rattled the windowpane. The surgeon tentatively sliced a small section of meat and raised the fork to his lips. He chewed the meat thoughtfully, his eyes wandering about the ceiling and upper walls as he did so. Finally he swallowed and, laying down his cutlery, dabbed at his lips with a starched white napkin. 'It's quite thoroughly cooked, Denise,' he said, his eyes suddenly settling upon his wife's troubled face. 'You need not worry so.'

'Oh, good,' said Mrs Piker-Smith, brightening, and with some gusto cut a potato in two. 'What have you been doing all morning, Evelyn?' she said, turning to her daughter.

'Oh, nothing.'

'Nothing?' said her father, eating.

'Just playing in the garden, Daddy.'

'What ever does the child get up to?' he murmured, as he transferred a spot of English mustard from the side of his plate to a neat rectangle of chop.

'Daddy,'

'Yes, Evelyn?'

'Are there still pygmies in the Congo?'

A frown briefly ruffled the calm surface of the surgeon's fine-domed brow, like a breeze whispering across a lake. 'I believe so.

Why do you ask?'

'Oh, school.'

'Are you doing Africa, darling?' said Mrs Piker-Smith.

'Sort of.'

'It's not called the Congo anymore,' said Daddy. 'It became Zaïre when the Belgians left.'

'When was that, Daddy?'

'Nineteen-sixty, I think.'

After lunch Evelyn always had to go to her room and read on her bed for an hour. Today she stood at the bedroom window, gazing into the garden and thinking about her explorer. White clouds fled like driven rags across the blustering blue sky, and the branches of the great elm at the bottom of the garden flailed about like the arms of drowning men. The Piker-Smiths' was one of those long narrow gardens enclosed by an old wall whose crumbling red bricks were overgrown with ivy. The path ran from the foot of the back-door steps between two flowerbeds and then twisted over a stretch of lawn before arriving at a small round goldfish pond, the surface of which was half-hidden by clusters of green-fronded water lilies. Beyond the pond a gardening shed, its windows misted with dust and cobwebs and its door secured by a huge rusting padlock, clung in ramshackle fashion to the corner formed by the east wall and the end wall. The rest of the garden beyond the pond was a tangled and overgrown mass of rhododendron bushes, into whose labyrinthine depths, since the death of the old gardener, only Evelyn now ventured. It was in that tangled thicket of evergreens that the explorer's tent was pitched, and there that the man himself lay struggling with a furious malaria. The three white sheets billowed in the wind, and for an instant Evelyn imagined the house and the garden as a great

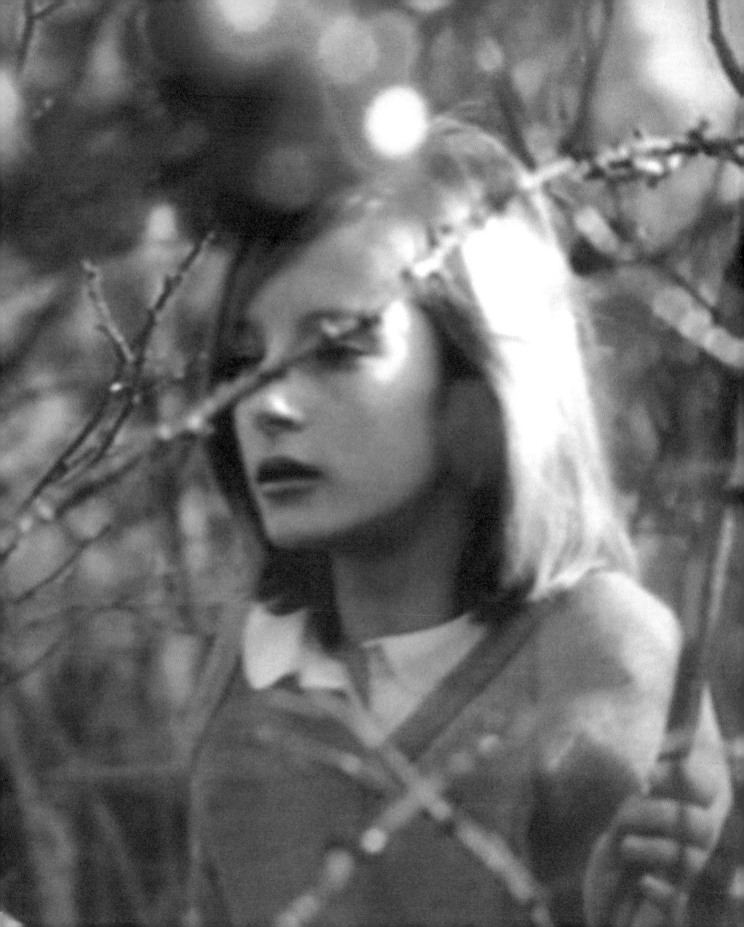

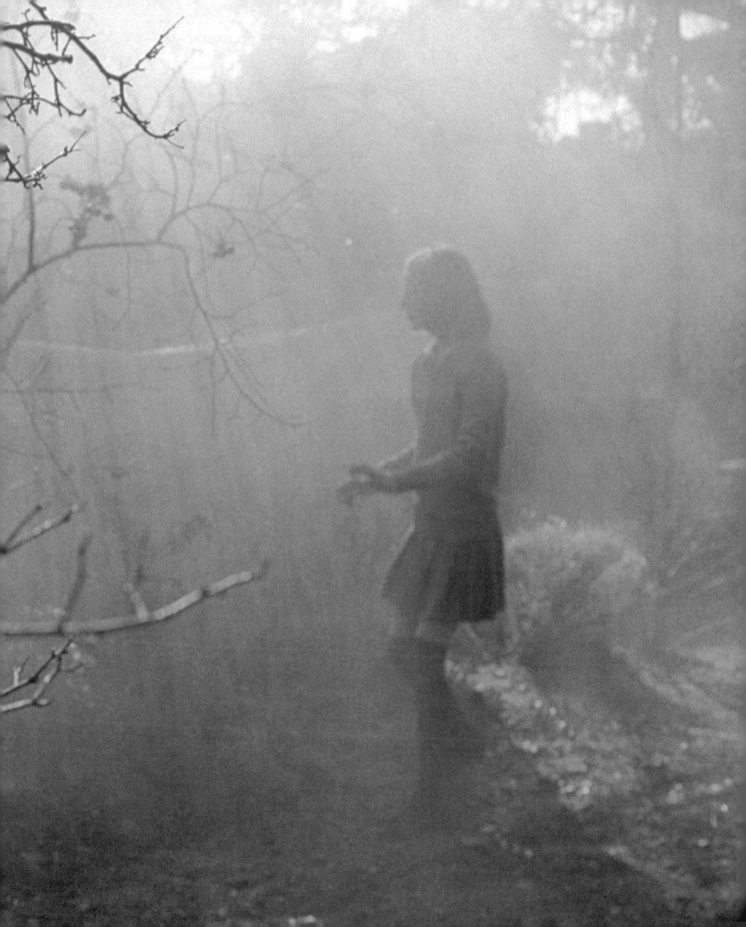

ship shouldering on to the tropics. Absently she picked up a jar containing a pickled thumb that Daddy had given her. She swirled it round in its liquid and willed the time to pass.

When her hour was up, Evelyn came downstairs to find Daddy in the hall just leaving for the hospital. He was telling Mummy something about dinner: the Cleghorns were coming and there was no sherry in the house. Then Daddy said goodbye and left.

'Now, darling,' said Mrs Piker-Smith, 'I'm off to my bridge. You'll be all right till Mrs Guppy gets back?'

'Yes, Mummy.'

Then Mrs Piker-Smith left too. Evelyn was alone. She was down the back-door steps in a flash, under the billowing sheets, across the lawn and into the bushes. The explorer was still fast asleep. Evelyn knelt beside him and watched his face with intense concentration for some minutes. Then her gaze drifted to the objects on his camp stool, and settled on the black revolver. She had never touched a gun before, and it fascinated her. She reached out hesitantly, and clasped it by the grip. How cold and slippery it was! And how heavy! She lifted it and pressed the barrel to her cheek. It smelled metallic and oily. She touched it once with her tongue, and recoiled with a small shock as she tasted its steely sweetness. Ugh! She cradled it in her palms, in her lap, and stared at it solemnly. How would you put bullets into it? She could turn the cylinder, but she could not release it. Perhaps this little catch...

Evelyn screamed: a large, scarred hand, dark brown, very dirty, with hair on the back and cracked fingernails, had clamped onto her own slim fingers and held them fast. It was the explorer's hand. He was up on one elbow, staring at her, and his harrowed face was clenched and twitching with anger. She gazed at him with wide,

shocked eyes. He took the revolver from her. 'And the bullet,' he growled, picking it from her open palm. He took the other bullet from the camp stool and then, his eyes darting from the girl to the revolver, he loaded two chambers.

'One for you, Agatha,' he said hoarsely, 'one for me.' He nodded several times. 'This way: quick – sure – painless. Better death, foil the pygmies, what.' He subsided onto his back, suddenly exhausted. His fingers twitched upon the sweat-stained canvas of the cot, and a sudden access of perspiration left him pale and dripping. His eyes bulged, then fixed upon a point on the roof of the tent. His whole body shivered, and a limp hand fluttered from the canvas like an injured bird. 'Agatha,' he moaned; and Evelyn, dropping to her knees, took his hand.

All afternoon the fever raged, and the explorer mumbled incoherently throughout. On several occasions he was convulsed with terror, and rose up shouting that the pygmies were hard by; but each time Evelyn calmed and soothed the troubled man, mopped his brow and gave him water; and in his few moments of lucidity he gazed at her with weak, shining eyes and murmured the name Agatha. For in the turmoil of his disordered mind he lay in a child's bedroom, in a child's bed, with a stuffed golliwog beside him, and a kindly woman in a sort of ruffled white cap and a starched white apron briskly ministering to his child's disease; and thus did Evelyn appear to him.

When the light began at last to thicken, and the dusk of that autumnal day crept into the explorer's tent and pooled itself in clots of shadow in the corners of the tent, a voice came calling, 'Evelyn, Evelyn!' The man stirred in his uneasy doze, muttering, and Evelyn leaned close to him. 'I have to go,' she whispered. 'Sleep now, and I'll come back…'

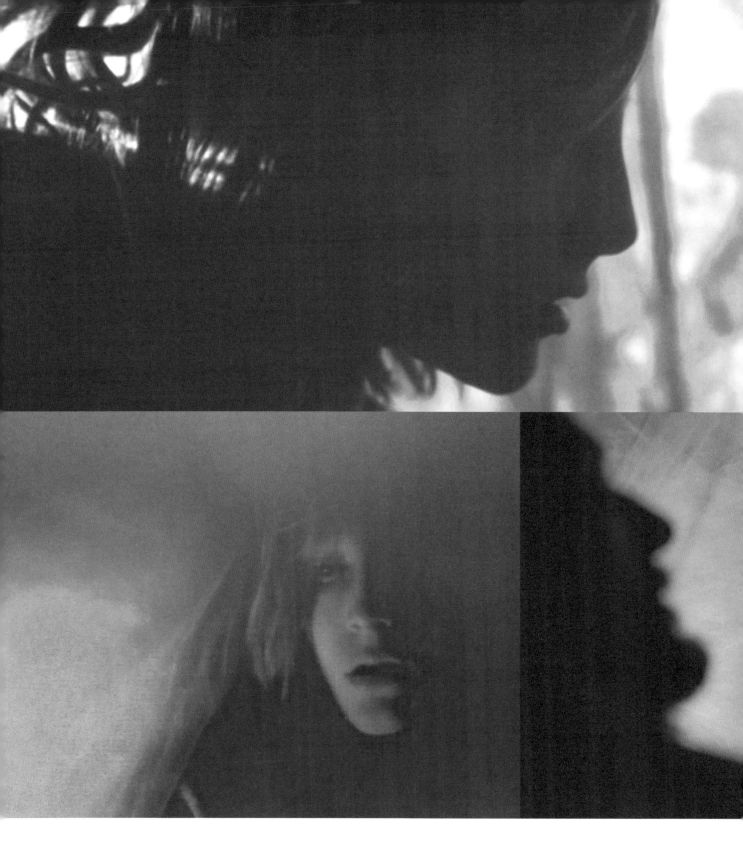

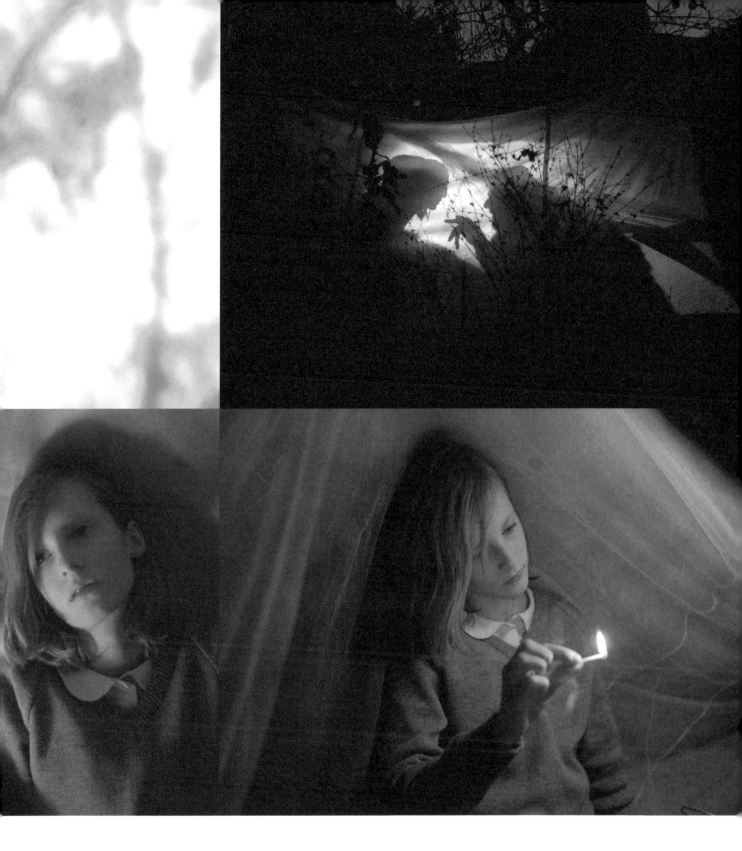

He seemed about to rise from the camp bed and cry out; his eyes opened wide for an instant; but then the netherworld of shadows and confusion reclaimed him, and he sank once more into sleep of a sort. Evelyn spread upon his twitching limbs the blanket she had brought out from the house; and then she padded silently away, through the bushes, and onto the path back to the house.

The Cleghorns were old friends of the family, so Evelyn was permitted to eat with the grown-ups. Mrs Cleghorn – Auntie Vera – was a large dark woman with good teeth. She wore heavy lipstick and was married to an anesthetist called Frank – Uncle Frank – a colleague of Gerald's. Mummy and Auntie Vera often played bridge together, and it was about bridge that they were talking when Evelyn entered the drawing room, just before dinner. Everybody was drinking a rather nice South African sherry, and Evelyn was invited to have a juice. Then Mrs Piker-Smith went to see Mrs Guppy in the kitchen, and as the two men drew aside to talk shop for a moment Auntie Vera's great black eyes swiveled round on Evelyn like a pair of undimmed headlights.

'Evelyn,' she cried, plumping a cushion with a large white hand. 'Come here and sit next to me. How is school?' Evelyn liked Auntie Vera, but she was rather in awe of her. She sat down on the sofa, pressing her slender legs together and clasping her hands in her lap. 'We're on half-term,' she said, looking at the carpet.

'Half-term!' cried Auntie Vera. 'How marvelous!'

'Yes,' said Evelyn with great seriousness. 'Do you know anything about Africa, Auntie Vera?' A coal fire crackled in the grate; above the mantelpiece hung a mirror, and invitations to social functions, mostly connected to the hospital, were tucked into the inside edge of the frame.

'Frank took me to Cairo for our honeymoon,' said Auntie Vera, taking Evelyn's hand. 'He pretended I was Cleopatra!' Evelyn turned toward her and found the great black headlamps shining with delight and the tip of Auntie Vera's tongue resting on her top lip.

Conversation at the dinner table ranged widely from the price of sherry to the price of beef. Gerald mentioned a rather interesting colostomy he'd performed after lunch, and Uncle Frank made some quips which might, in a nonmedical household, have been taken in rather bad taste. Only once did Evelyn pay any attention, and that was during the main course, when Auntie Vera turned to her husband and said, 'Frank, Evelyn is interested in Africa.'

'*Is* she?' said Frank Cleghorn.

'Not all Africa, Uncle Frank,' said Evelyn. 'Just the Congo.'

'Ah, the Congo!' said Uncle Frank fatly, and began to tell the story of Henry Morton Stanley, digressing rather amusingly to mention the tragic shooting death of John Hanning Speke mere hours before the eagerly awaited debate with Richard Burton on the source of the Nile; that was in 1864. Evelyn was sitting opposite Uncle Frank, who had his back to the door of the dining room, which was half-open; as Evelyn half-listened to his affable drone, she suddenly saw, over his shoulder, pausing in the doorway as he shuffled towards the stairs, the explorer. He turned his head and stared at her. Fortunately, she did not cry out; Auntie Vera was deep in animated bridge talk with Mummy, and Daddy was concentrating on a delicate incision he was about to make in a slice of reddish beef. Uncle Frank warbled on, and in the doorway behind his back stood the haggard, feverish man, and oh, how ill he looked! His head hung weakly on sagging shoulders; his eyes burned with a low, sickly gleam out of sunken sockets in an unshaven face deeply etched with the gullies of suffering.

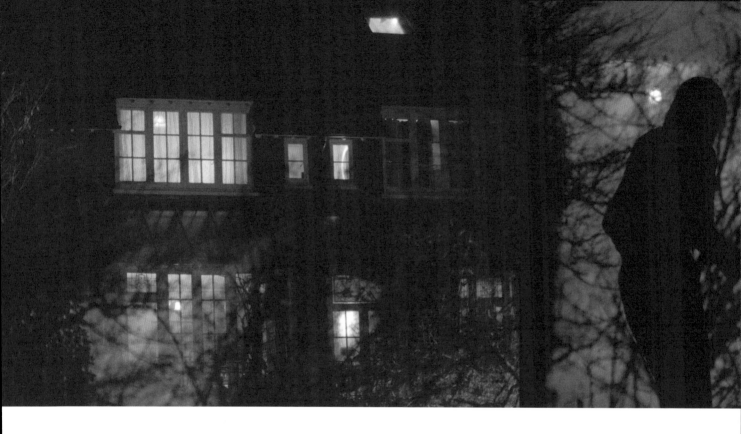

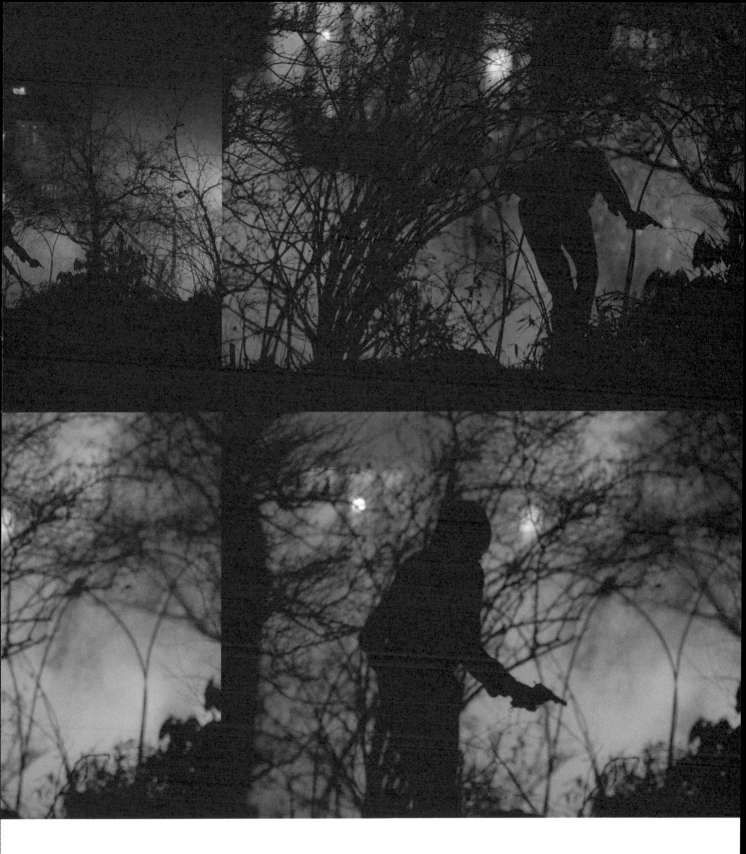

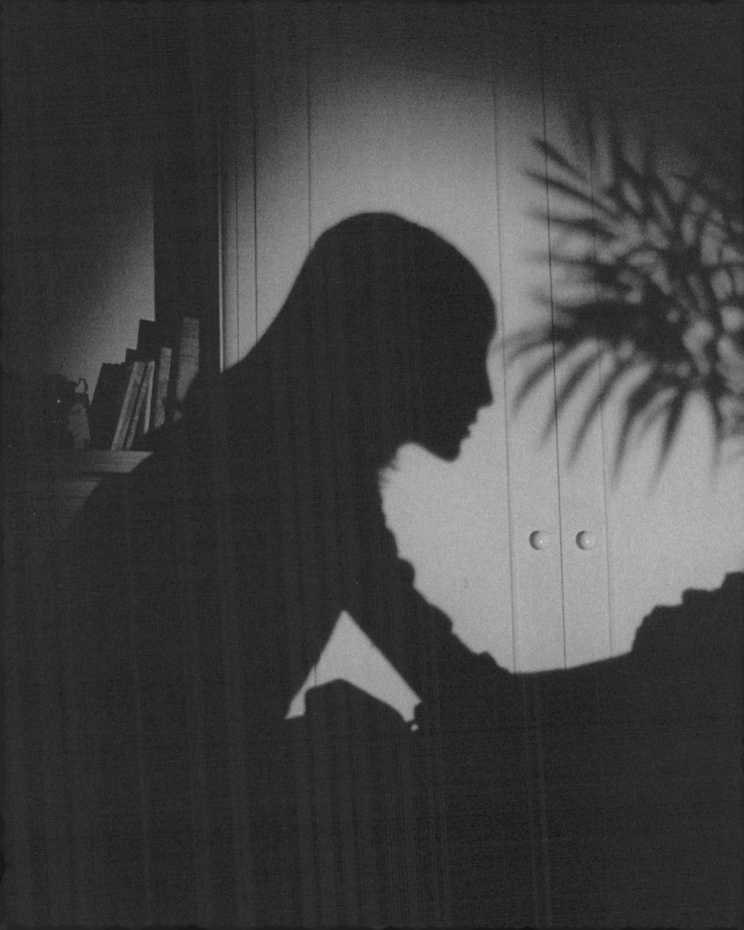

His clothes looked extraordinarily ragged and filthy against the beige-flowered wallpaper of the hallway, and his scarred, grimy hands still twitched convulsively where they dangled at his sides. Evelyn stared at him wide-eyed, and Uncle Frank was flattered at the raptness of her attention. It was only after some moments that he realized her eyes were focused not upon his own but beyond them; and he began, even as his discourse flowed forward, to turn in his seat. But at precisely the same instant the explorer shuffled off down the hallway out of sight; so that Uncle Frank, seeing nothing, turned back and talked on. Daddy, having completed his incision, lifted his fork and his eyes and turned to the anesthetist as his teeth closed upon the meat; and Auntie Vera lifted her wineglass while Mummy peered anxiously into the gravy boat.

When at last Evelyn was able to get away, she dashed upstairs; and as she had half-feared, and half-hoped, the explorer was in her bedroom. Not only was he in her bedroom, he was in her *bed*, fully clothed, the sheets up to his chin. His teeth were chattering loudly and his whole body shivered beneath the bedclothes.

'Cold,' he grunted as Evelyn closed the door behind her and ran to the bed. 'Cold, Agatha,' he said more clearly, and she reached under the bedclothes for his hand. It was frigid. Something else was down there too – she felt the hard metallic bulge of the revolver, stuffed into the explorer's waist-band. 'Let me have the gun,' she whispered.

A tremor passed across the pathetic features of the dying man. 'Need will,' he muttered. 'Need will to do it. Pygmies...' Here he paused, and his chest heaved painfully with the effort to talk, the effort to think. Oh, how he wanted simply to slip away, let go, sink into peace and rest and silence and darkness! – but he could not let go, not yet. 'Pygmies,' he said, more loudly, and Evelyn with terror clapped her hand upon his parched and cracking lips. The wild eyes

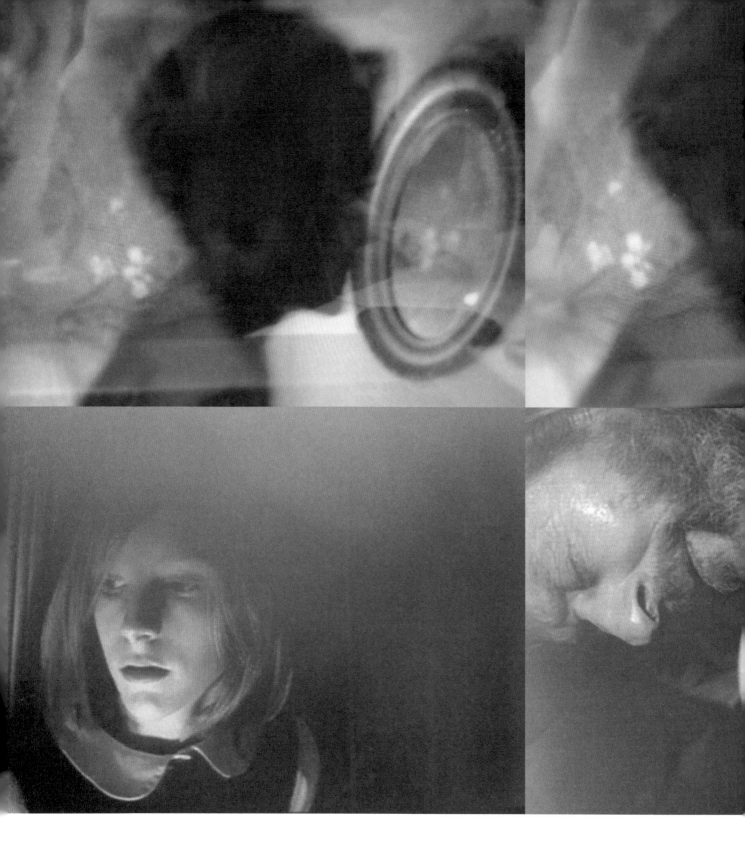

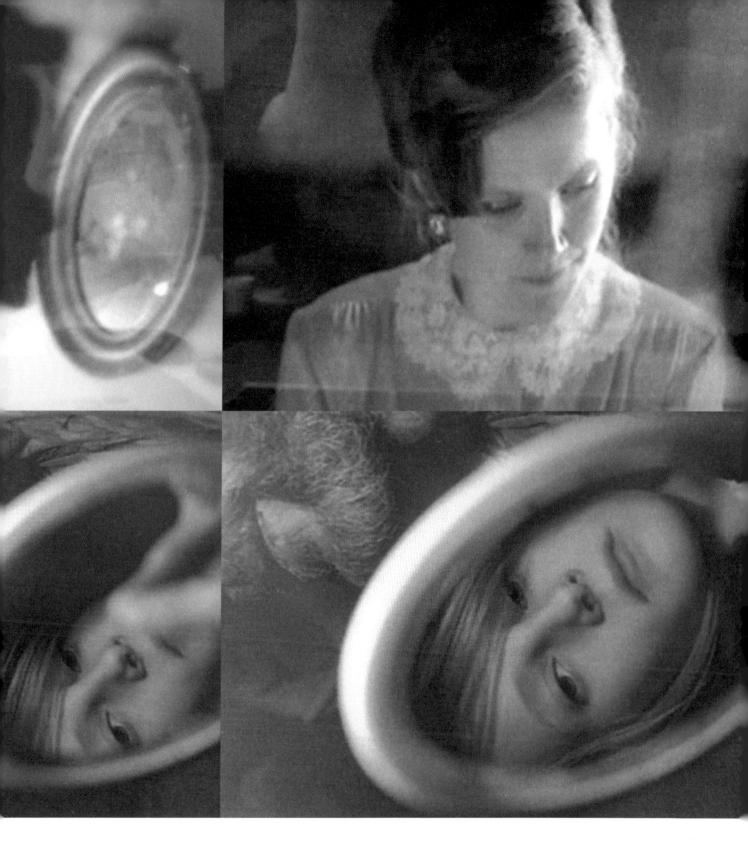

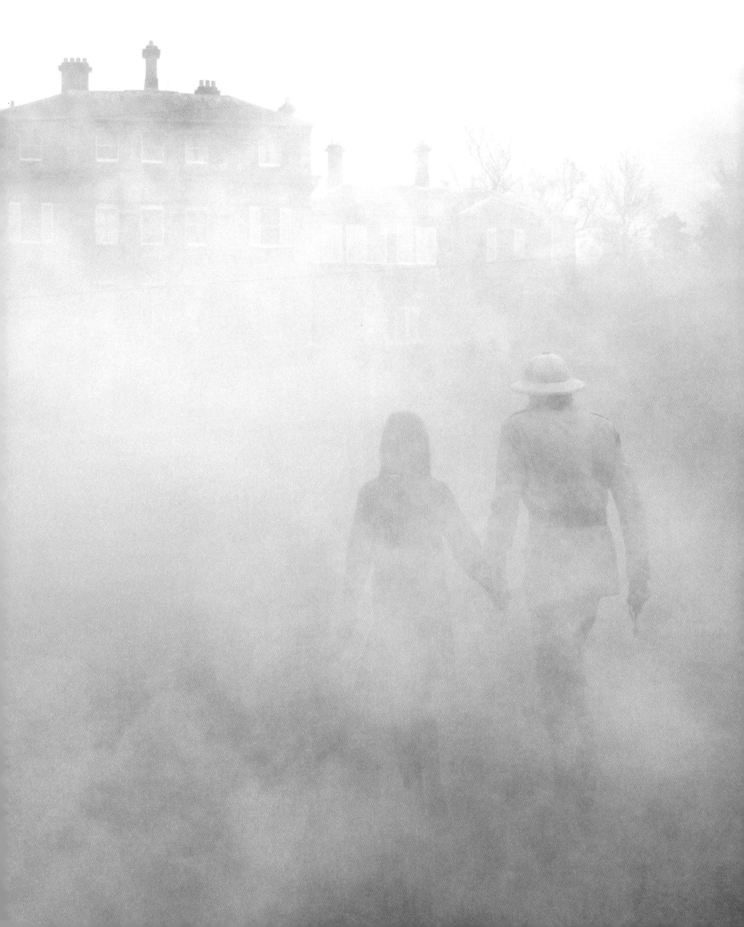

darted to her bedroom door. He knew they were near. 'Pygmies,' he whispered, when she lifted her palm from his mouth. 'Coming to eat us. One for you, Agatha, one for me...'

'Don't talk,' said Evelyn, her finger to her lips. 'We won't be eaten. Sleep. I'll give you a drink.'

Evelyn fetched a drink of water, and the explorer's eyes, as she supported his shoulders and held the cup to his lips, rested on her face with an expression of such profound pain, and gratitude, and spirit that it tested the girl's mettle pretty sternly. But she did not flinch nor falter, and when he had drunk she eased his head back onto the pillow and stroked his chilly brow.

'Agatha,' he murmured, 'Agatha,' and his grip on her fingers loosened very slightly.

The rest of that evening was nerve-racking for Evelyn. She went downstairs to say good night to Uncle Frank and Auntie Vera, and to Mummy and Daddy, and then darted back up to her bedroom. She could only hope that Mummy wouldn't come to tuck her in tonight; it was something she did occasionally, by no means invariably. Evelyn made up a bed for herself on the carpet, and turned off the light. The explorer seemed to be sleeping soundly. She listened in the darkness for Mummy and Daddy coming up to bed. Daddy was first; she heard him brushing his teeth in the bathroom. Then Mummy came up, and stopped at the top of the stairs. Evelyn's heart was beating fit to burst; hot chemicals discharged and flooded in turmoil about her viscera; go to bed, Mummy, a voice in her brain screamed silently, *go to bed, Mummy!* Steps across the landing, and then – *a hand on Evelyn's door handle!*

The tension, in the few moments that followed, was, to Evelyn, lying there in the darkness, her eyes wide and her stomach awash

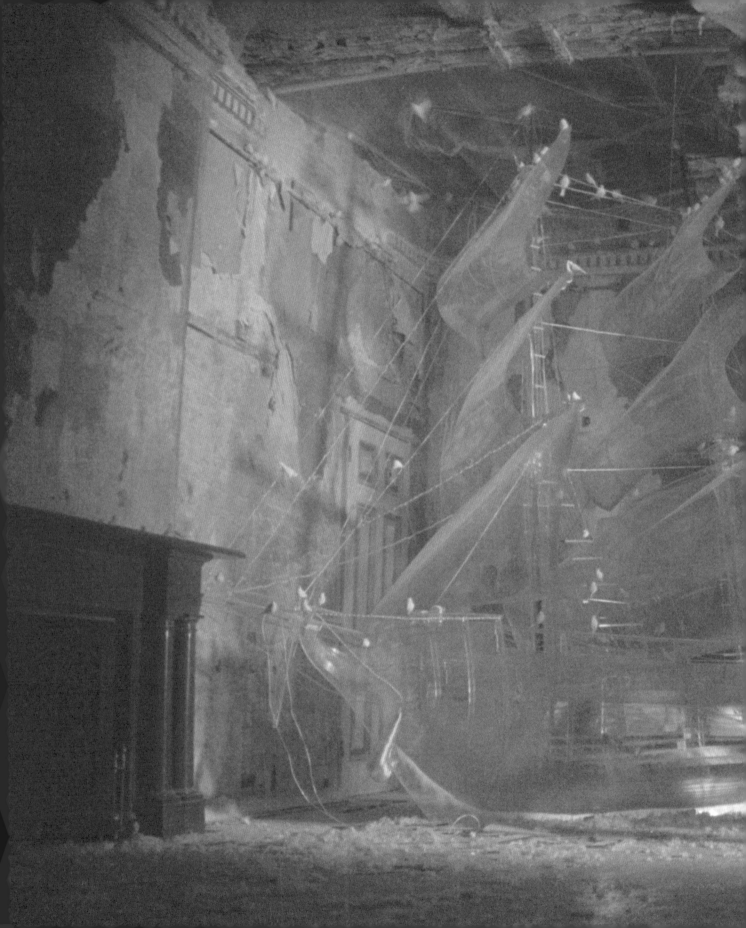

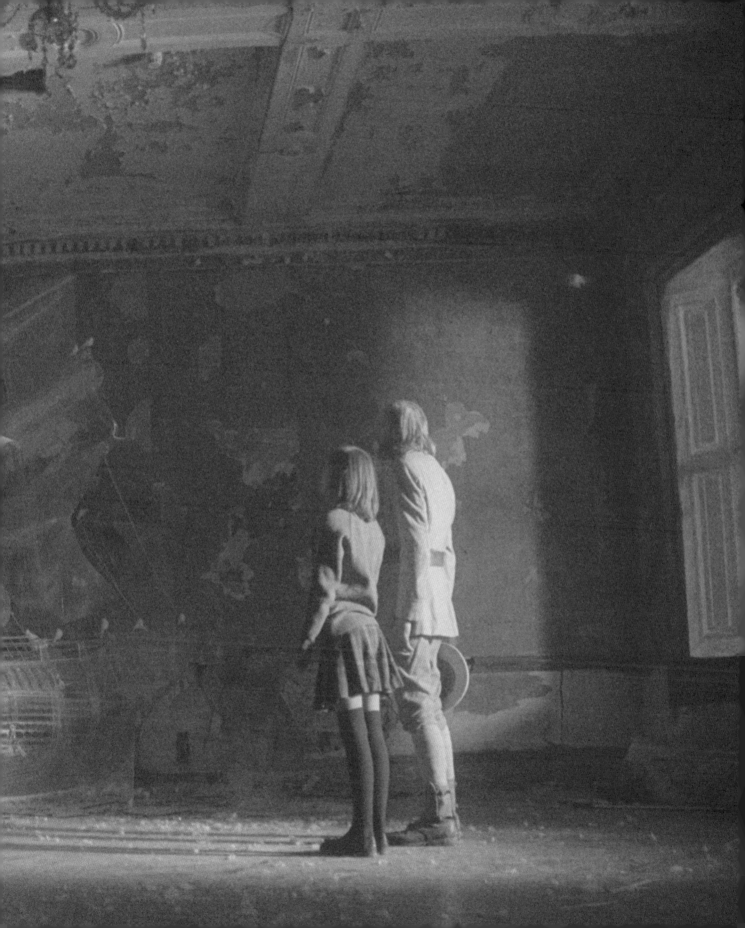

with adrenaline, almost unendurable. Frightful scenarios unfolded at lightning speed in her febrile imagination. How could Mummy and Daddy be expected to understand about the explorer? And the gun! What if –

'Denise!'

Even as the handle turned, her father's voice called from the bathroom.

'What is it, Gerald?' replied her mother in hushed tones.

'Have we any dental floss?'

'On the shelf, dear.' The door handle was still depressed; Evelyn desperately wanted to go to the bathroom herself.

'No, I don't see it.'

'Oh, Gerald,' murmured Mrs Piker-Smith; and, wifely duty superseding maternal solicitude in the ethical hierarchy of that good woman, she tiptoed to the bathroom and located the dental floss. A short conversation about the beef ensued; and then Mrs Piker-Smith went into the bedroom, closely followed by her husband, and their door, to Evelyn's immense relief, closed behind them. But it was another excruciating hour before she dared get up and creep to the bathroom.

The next morning the explorer was dead. Silently, and, one hopes, peacefully, in the middle of the night, he had passed away. Evelyn awoke at six and realized it immediately. He was stiff and staring, and when she laid her hand upon his face, his skin was even colder than it had been last night. She closed his eyes; and then she lay on the bed beside him, on top of the blankets, and she wept quietly for ten minutes. She wept into her blankets as the fact of the loss of that long-suffering man rose up starkly in her heart, and she wept too for herself, for she was desolate. Her sorrow was keen, but it would not fester; and when she rose from her bed,

wet-eyed and gulping back the hot taste of grief in her throat, she tried to think clearly what was best. But first she must air the room, and the bed, and change the sheets, for the stink of a man too long in the jungle hung heavy in Evelyn's bedroom.

Fever had weakened him, diminished him, and the body was light. Evelyn, though skinny, was strong from hockey, and she dragged him from the bed to the closet quite easily. She sat him in the darkest corner, covered him up with a pair of old school raincoats, and pushed all her clothes to that end of the rail. Then she opened wide the windows, stuffed the sheets into her laundry basket, and climbed under the blankets, where she lay in a state of rising anxiety till Mummy should come to wake her.

'Darling, you'll catch your death!' cried Mrs Piker-Smith when she came in at half past eight. The windows were wide open and the day was very blustery indeed. The curtains flapped wildly and the air was chill. Even so, there were traces. 'What's that funny smell, darling?' said Mummy, standing by the closet door and wrinkling her nose. Evelyn, simulating a slow awakening, mumbled incomprehensibly from the bed. Mrs Piker-Smith stood frowning a moment more. 'It must be your hockey things,' she decided. 'Give them to Mrs Guppy, darling, and they'll be clean for school.'

Mumble.

'It's eight-thirty, darling' – and she went downstairs.

*

Evelyn stood panting in the tent. All morning the explorer had remained in her closet, and those hours had not been easy for the girl. But after lunch Daddy had gone back to the hospital, Mummy had gone to her bridge, and Mrs Guppy had gone shopping. Evelyn breathed a prayer of thanks that all their lives were subject to such seemingly immutable routine.

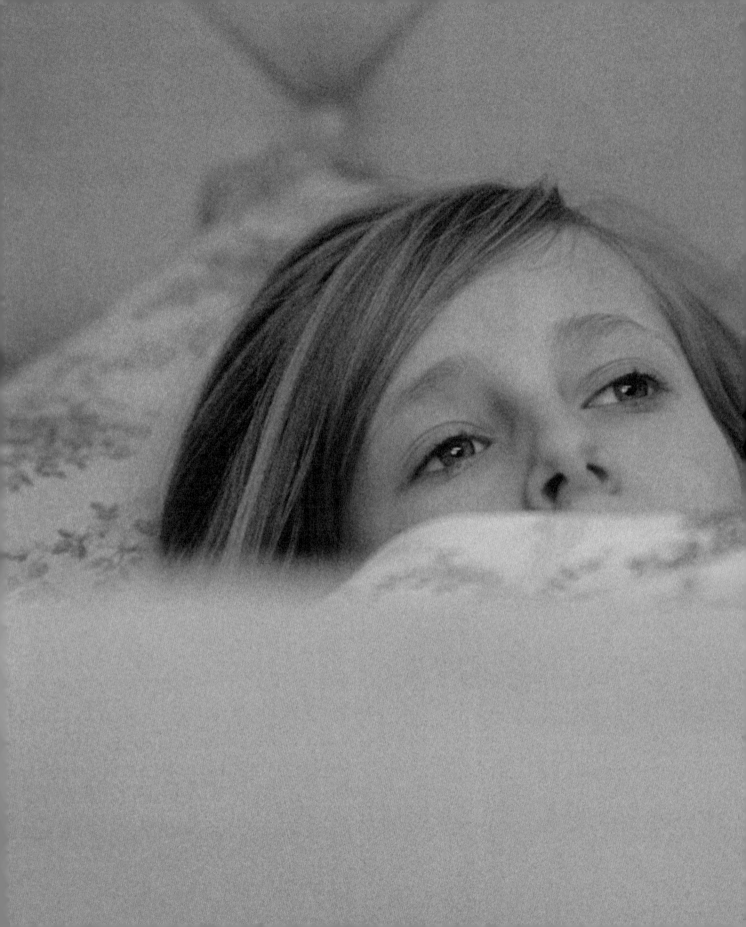

She'd hauled him out of the closet then and dragged him downstairs. She'd moved slowly, backwards, clutching him by the armpits. His head lolled about on his chest and his feet bumped limply on the stairs. In death he seemed so small, so light, that Evelyn was again unhappy, and her eyes brimmed with tears as she dragged him across the linoleum of the kitchen floor. She laid him down for a moment and went for a glass of water. Over the sink was the kitchen window, and it looked down on the garden. Mrs Guppy had brought in the three white sheets; her own sheets had not yet replaced them; instead, the line was alive in the wind with her parents' underwear. The elm at the bottom of the garden was once more whipping its limbs about. A large Persian cat paused upon the wall by the gardener's old shed, then stalked off with dignity, picking a path along the top of the wall with its tail stiffly aloft. Evelyn had drunk her water and then manhandled the explorer down the steps, between the flowerbeds, across the lawn and round the goldfish pond, into the bushes and so to the tent. And now she would bury him.

Evelyn had long since broken open the old padlock on the shed door, and it hung there now only to hold the door. She slipped it out of the eye and the door swung open. A damp, fetid smell, dusty, earthy, filled the shed. The light with difficulty penetrated the place; a large heap of sacks moldered gently in the corner, and the old plank floor was suspiciously damp thereabouts. Evelyn had once poked about in that corner, but now she tended to avoid it, for the floor was rotten beneath the sacks, and the three substances, sacking, wood, and the earth beneath the rotten wood, had begun to coalesce, as if attempting, in their nostalgia for some primeval state of slime, to abandon structure and identity, all that could distinguish or separate them. Other signs of regression and breakdown were manifest in that dusty old shed; upon the

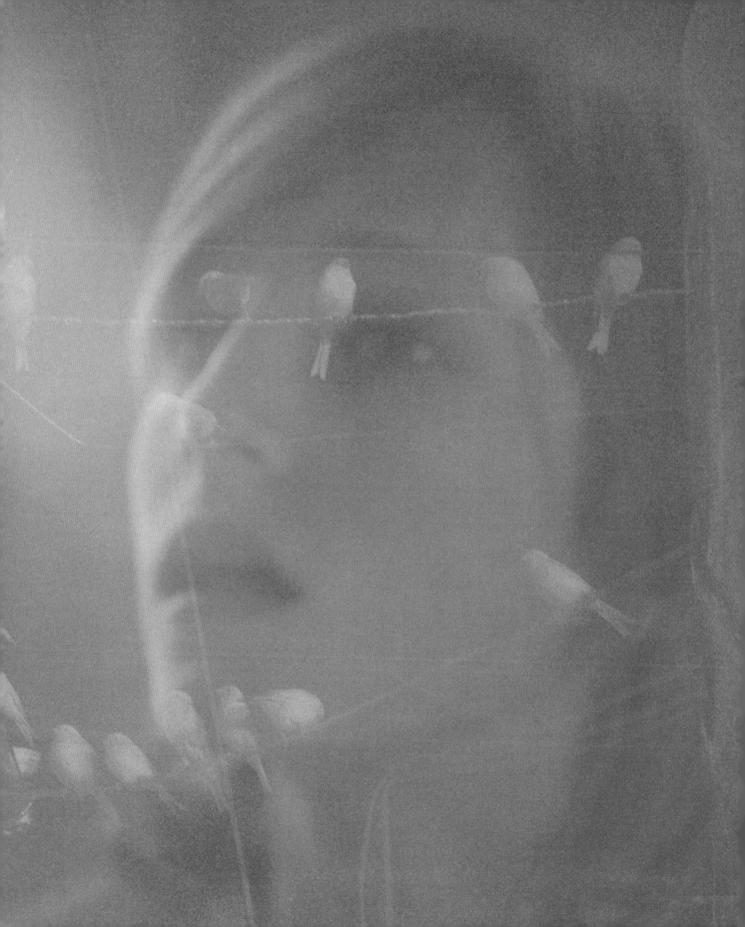

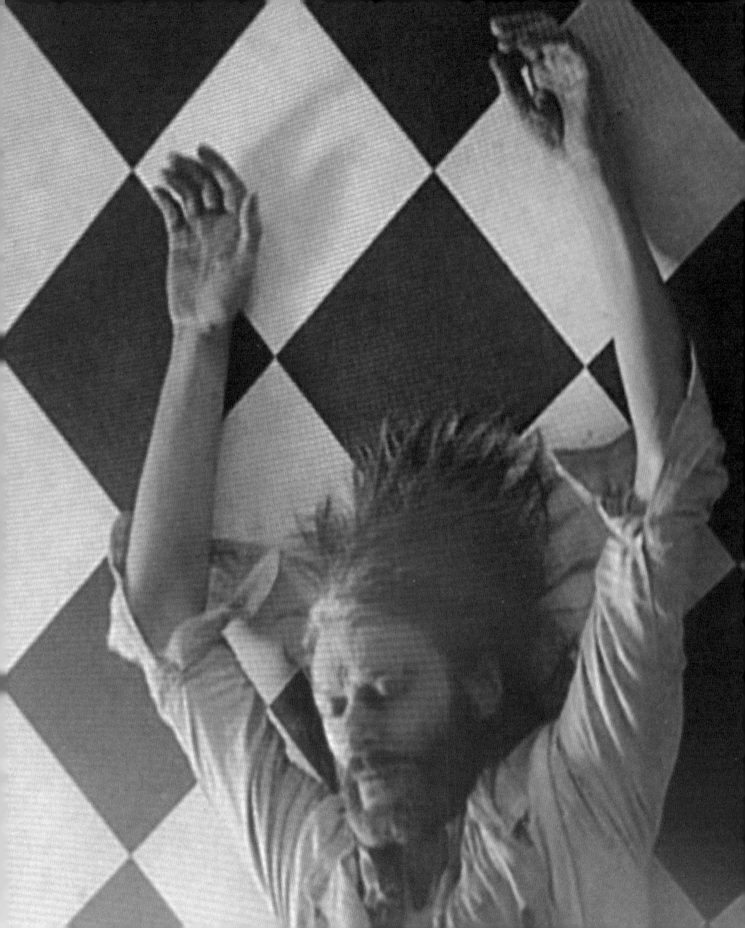

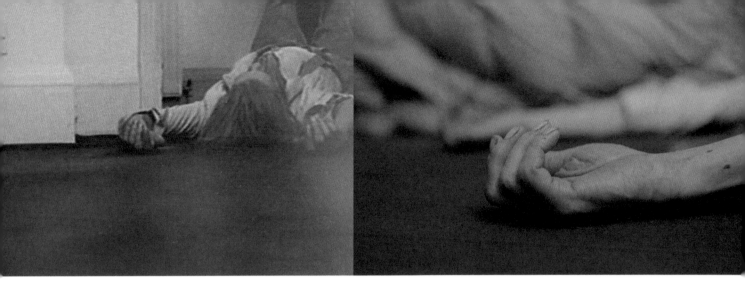

windowsill, beneath the vast network of cobwebs, lay the stiff little corpses, some partially digested, of flies and other small winged insects, many with their tiny legs curled pathetically over them as if in a final and futile gesture of self-closure. An old cardboard box, moist with decay, was damply merging with the wall, and in it a heap of parts from some long-forgotten automobile engine congealed blackly rigid, petrifying like coal as the work of time and damp smudged them with rust and rendered their decadent inutility ever more irrevocable. Photographs had once been pinned to the wall of the shed; these now curled at the edges like the legs of the flies, and as regards their degenerated content barely a trace could now be detected of the humans who had stood, once, before the camera, vital, one presumes, and alive. It was as though they had died in the bad air, the malaria, of that neglected little corner of the garden, the thin dusty air of the old shed, within which everything must devolve to a fused state of formless unity...

But Evelyn had no time to relish regression today. She stepped across the floor and seized up a spade, its blade spotted orange with rust but its handle as yet sturdy and whole. This she took

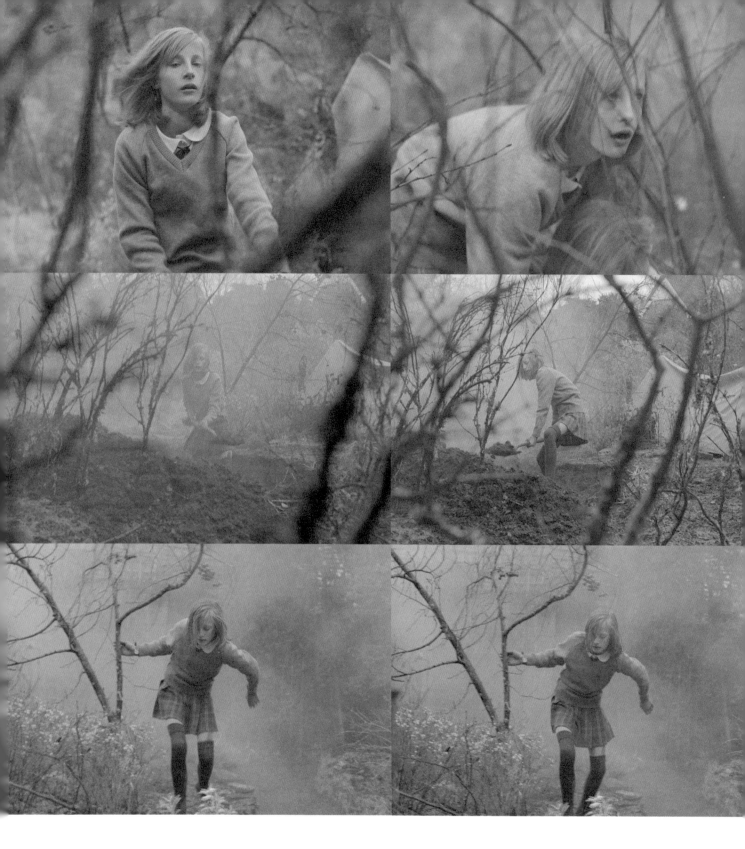

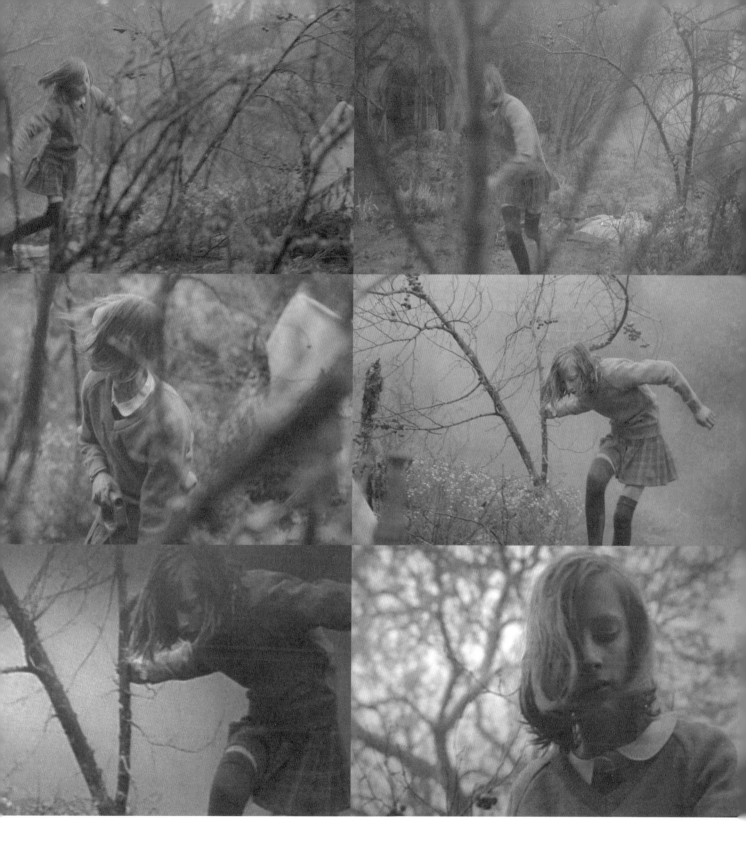

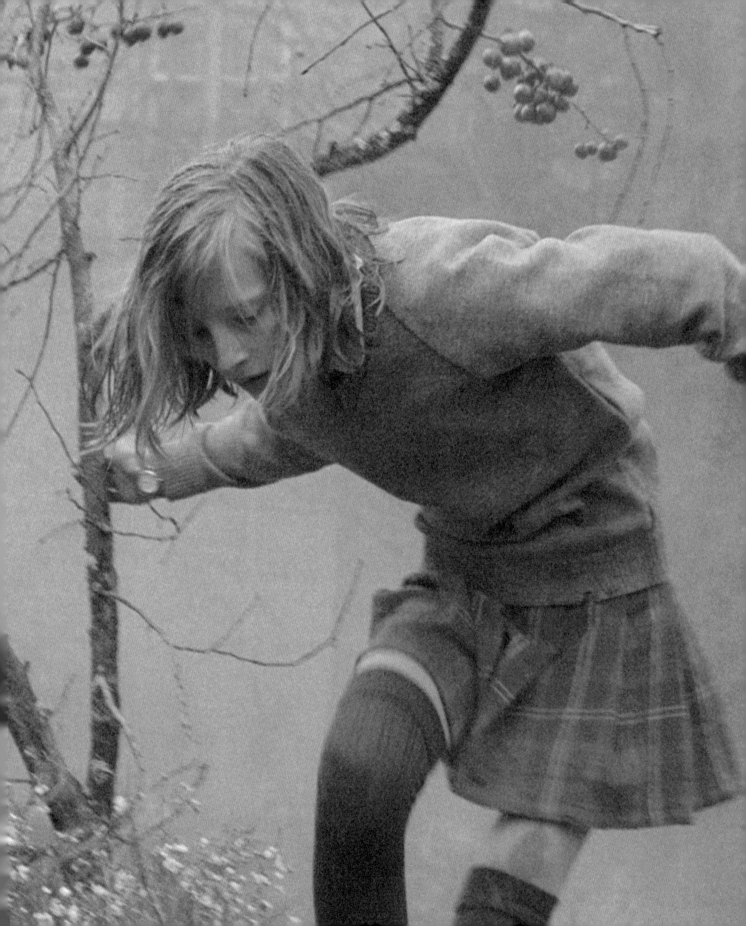

from the shed and, closing the rickety door behind her and replacing the great padlock, ran back through the windy sunshine of that October afternoon and again entered the bushes.

And now she worked briskly and methodically. She collapsed the filthy tent, noticing as she did so the multitudes of tiny equatorial insects clustering in the seams and corners. She dropped it in the corner of the clearing, and then laid the explorer upon it, and his bed beside him, and then the camp stool with its few pitiful possessions – remnants of the explorer's last wild dash from the Congo, pursued by anthropophagous pygmies who had once existed either in the reality of that far jungle or in the fevered mind of her strange and needy visitor, Evelyn could not know which. And then she dug. For two hours she dug; her young limbs strong from hockey, she tore a steadily widening, steadily deepening hole out of the earth in the center of the clearing in the midst of the rhododendron bushes at the bottom of the garden. And when she was finished she lined the hole with the tent. And then she burned that old map of his, creased and sweat-stained; she set it afire with the odd vestas he had left on the folding stool, and the ashes fell into the pit. And then she tossed in the gun, having hauled it with a sob from the dead man's waistband; and then the flask and the oil lamp, and then the man himself, into his grave, but not unmourned, and maybe this is all that any of us can ask for.

She saw him, occasionally, in the months that followed, always from her bedroom window when the moon was up. He'd be standing at the goldfish pond, his face pale and gleaming in the moonlight and his hands twitching at his sides. He'd look up at her window and she'd slowly move her palm back and forth in greeting. And though the fever was still upon him, he seemed no longer in mortal fear of the pygmies – yes, a subtle theme of peace had

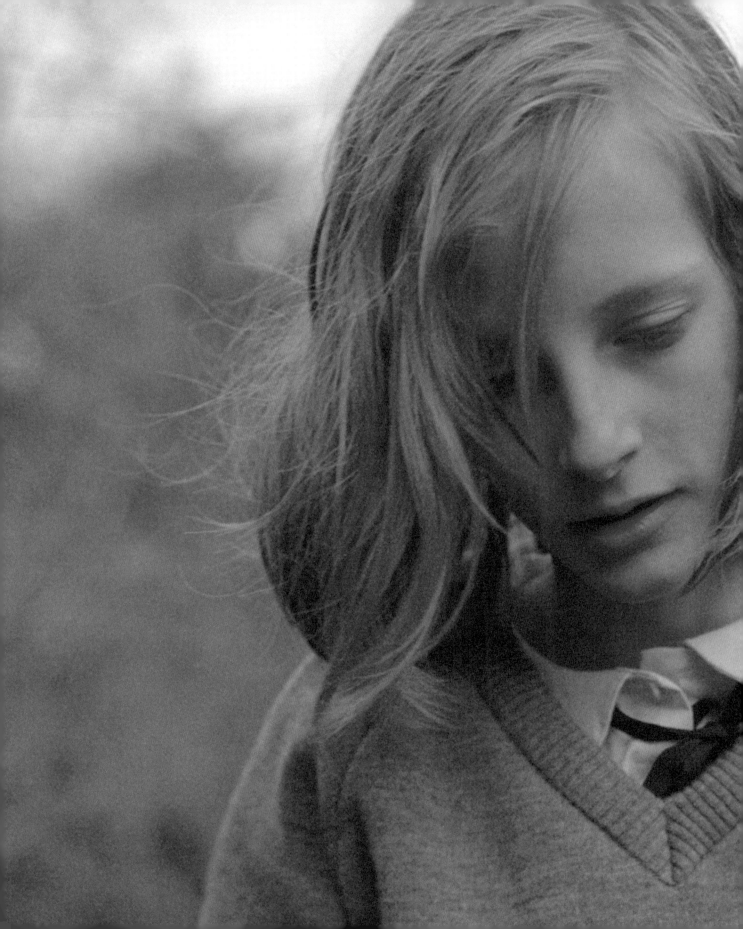

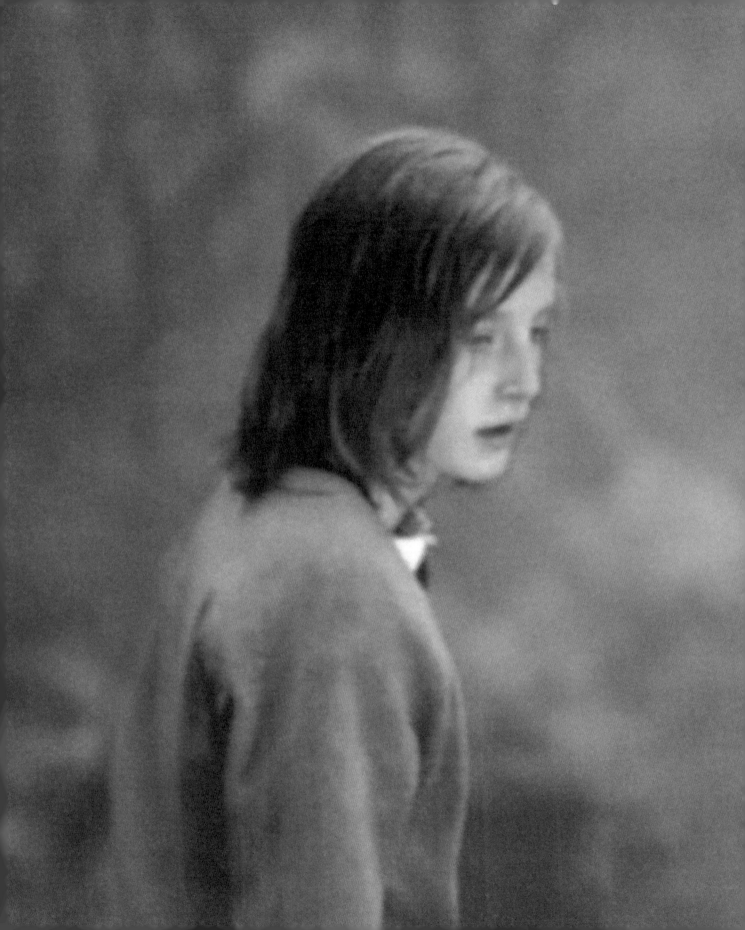

entered the symphony of his diseased being, if being indeed he was.
Perhaps, after all, he was nothing; Evelyn began to see him less
and less frequently after that, and at around the time – she'd
have been about fourteen-and-a-half then – the time she decided
to become a doctor, he disappeared from her life completely,
and she never saw him again.

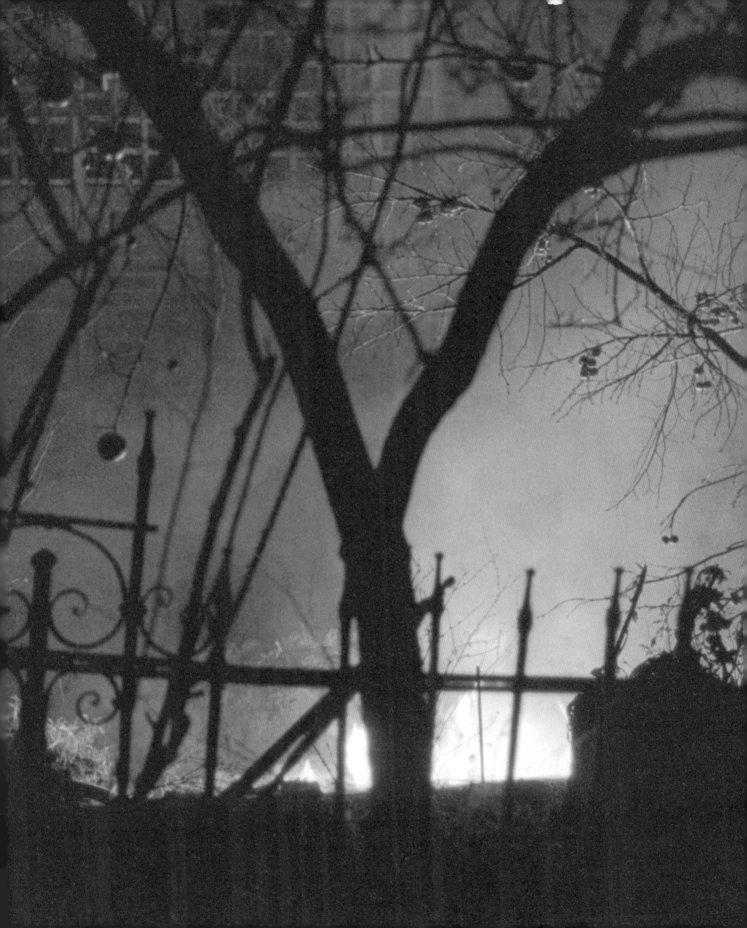

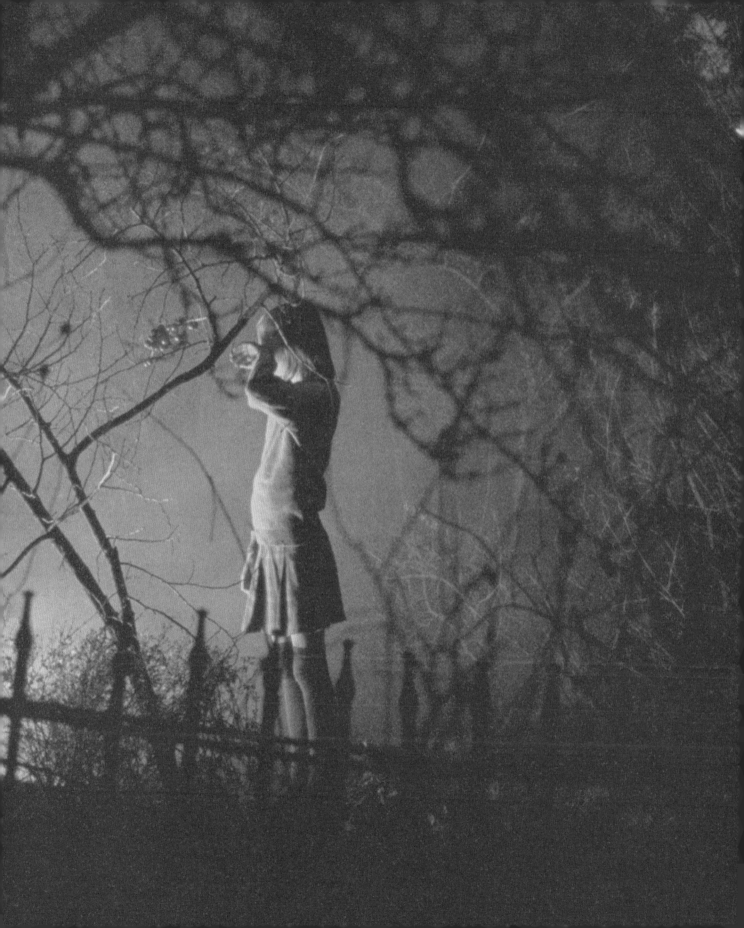

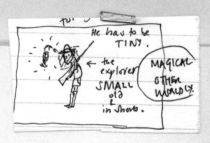

THE LOST EXPLORER

by

Kit Hesketh-Harvey and Tim Walker

(Based on the short story, THE LOST EXPLORER by Patrick
McGrath)

Rufus Ltd.
16 Gibraltar Walk
London, E2 7LH.

INT. EVELYN'S BEDROOM WINDOW. LONDON SUBURBS. LATE AFTERNOON

Sheets flap wildly in the wind, and swaying trees are shedding their leaves in showers outside the upstairs bedroom window, out of which a girl (EVELYN, 11 only child of ELISABETH & GERALD PIKER - SMITH) is staring.

pulls back from Evelyn & her

The camera tracks across Evelyn's bedroom. Books are predominant. The camera zooms in *focuses* on the spines of some of the titles on EVELYN'S book shelf. "TREASURE ISLAND", "KING SOLOMON'S MINES" etc. Her desk is littered with Geography and Biology homework fluttering in the wind of her open window.

Fluttering Book
Cover of Book
The best explained / cover credits.....
single
tight

EVELYN has a hand on her desk holding open a page of 'ROBINSON CRUSOE'. Her eyes are torn between the pages of the book, the excitement of the wind outside.

the book on his desk. Born

map of africa in Room

CAMERA pans down to reveal EVELYN'S mother ELISABETH PIKER-SMITH, a woman in her 40's, kneeling down pinning the hem of a blue velvet dress with a 'Peter Pan' collar. The dress is clearly tight & restrictive.

 ELISABETH PIKER-SMITH

Evelyn fidgets / unfocused

 Evelyn!

 Evelyn!
 (Reinforced yet softer)
 Darling, will you PLEASE stay
 still.

EVELYN grimaces and strains at her reflection in the mirror. She shuts ROBINSON CRUSOE & looks down.

C/U OF PINS & DRESS HEM.

A pin clearly pricks EVELYN'S leg. EVELYN contains the pain with a sharp intake of breath and a more enthusiastic, longing stare out of her bedroom window. She doesn't scream out.

 ELISABETH PIKER-SMITH (CONT'D)
** did It catch you?*
** did I prick you*
(Pins in mouth)
 Sorry darling, now stay there and
 let me look at you.

ELISABETH PIKER-SMITH stands up, brushes her tweed skirt flat and recomposes as she contemplates the mother and daughter reflection.

 ELISABETH PIKER-SMITH (CONT'D)
 Well done, now step out carefully I
 can stitch the new hem for tonight.

Not enjoying the oppression of the dress EVELYN pulls it off with spirit and speed.

 ELISABETH PIKER-SMITH
 C-A-R-E-F-U-L-L-Y, or the pins
 will get you.

keep peter Panshirt on

socks: grey skirt / checked. grey jumper

EVELYN whips on her tomboy attire all the time looking to the garden. She leaves the dress and runs to the door. ELISABETH PIKER-SMITH, rolling eyes, gathers the discarded blue velvet dress.

EXT. GARDEN AND TENT. DAY

The long garden of this London house on a fresh and gusty
day. A washing-line is strung from a post at the top of the
steps. To this line are pegged three white sheets, flapping
wildly in the wind.

Through the sheets emerges EVELYN, aimlessly zigzagging in
her tomboy outfit, a little lost and floating towards the
tangled thickets at the bottom. She steps back in surprise.

At the bottom of the garden, lost in a mass of tangled,
unkempt garden, stands a small white tropical tent, of
imperial Edwardian aspect.

EVELYN'S eyes widen, she momentarily glances back up to the
house and she moves continuously forward.

 EXPLORER (faintly off screen) < The 'IN'
 Help me....

EVELYN bends down to open the tent's entrance.

(handwritten notes in margin:)
2
did we get
Evelyn's P.O.V.
Evelyn's Mini journey
FEAR
↓
BRAVERY
↓
CARE

⊛ She glimpses in him a vulnerability which determines he needs help
Evelyn is shocked by the L. Explr appearance - he is WEAKER - this gives her the
confidence and the 'in' to find SPIRIT & STRENGTH

INT. TENT. AFTERNOON

White flapping canvas, An EXPLORER in his late 60's lies
thrashing beneath a gaping and torn mosquito net. He is
delirious with fever. His tropical clothes are stained with
sweat and blood, and a grizzled beard stubbles his emaciated
face.

The canvas and netting parts to reveal EVELYN with the sun
behind her, lending her the appearance of a bright,
ministering angel. She cautiously looks in and glimpses in
him a vulnerability. He coughs.

C/U EVELYN. She is healthy and capable. For the first time
she focuses, concentrating her gaze on the EXPLORER, as she
tidies and straightens up a fallen stool and lamp. EVELYN
thinks THE LOST EXPLORER is wonderful. And he thinks she is
wonderful too.

 EVELYN
 Where have you come from? Are you DRy lips
 ok?

 EXPLORER
 (Mumbling & thrashing,
 talking nonsensically)
 Water...

(handwritten notes in margin:)
3
* But he
doesn't look
terrifying -
More "HANDSOME
FALLEN FIGURE"
Regal
proud
gentle - weak -
EXPLORER - not a villain

EXT. GARDEN. DAY

The branches of a great tree flail about.

EVELYN emerges from the tent with a sense of purpose. She walks hurriedly up the garden to the house.

POV EVELYN THE THREE WHITE SHEETS BILLOW IN THE WIND, ENGULFING HER.

DISSOLVE INTO:

INT. TENT. DAY

Get interior of, or shot from within tent

The tent flaps similarly.

EXT. GARDEN. DAY

EVELYN scampers up the back steps towards the kitchen door. Dead leaves swirl about. She opens the back door.

INT. KITCHEN. LATE AFTERNOON

We are in the kitchen of a middle class suburban house in West London. It is timeless (but styled towards suggesting the 1960's). In the immaculate kitchen, ELISABETH PIKER-SMITH is competently braising a joint of beef and stirring the roast potatoes. The meat sizzles.

WE PAN OFF them AS EVELYN enters the kitchen, She momentarily studies her mother's tweedy backside bending over the oven.

 ELISABETH PIKER-SMITH
 There you are - get upstairs and
 get changed. The Cleghorns are due
 here in 10 minutes. *CLOCK TICKING*

Evelyn - with her new connection is much nicer & jollier. Her needs are met.

EVELYN goes to a cupboard, having pulled up a chair, jumping up she reaches on tiptoe gets a large glass, goes to the tap, pours a glass of water, & smiling enigmatically, exits with it through the back door. EVELYN'S needs have now been met by her discovery of THE LOST EXPLORER. She is no longer lonely and isolated. She has discovered a connection.

 EVELYN
 I'll be back in five minutes, I
 promise.

ELISABETH PIKER-SMITH looks up and sighs as she watches EVELYN through the kitchen window.

INT. TENT. DAY

EVELYN has returned to the tent with the water. She folds
back the ragged netting and helps the EXPLORER onto an elbow.
He drinks. Much of the water spills onto his bush jacket. He
lies back exhausted. — *At this point he shows WARMTH & HUMOUR — he
coughs — Evelyn attends — but he reveals a cricket in his hand with a smile*

C/U: EVELYN GAZES DOWN AT HIM WITH BENEVOLENT COMPASSION. SHE
TAKES THE EXPLORER'S CLAMMY PALM IN HER FINGERS.

? "THANK YOU MY CHILD" Thankyou

C/U: A SMILE HOVERS OVER THE EXPLORER'S CRACKED LIPS BUT
THEN, SEIZED SUDDENLY WITH A FRESH WAVE OF PANIC, HE STARTS
UP FROM HIS BED.

⑧

** IMPORTANT **
*That he feel that
The LOST EXPL'
Loves Evelyn &
Vice versa —
There needs to
be real "BEST FRIENDS" so
when he dies we
feel Evelyns Loss.*

 EXPLORER
 The pygmies! *Looking LOST and confused — hiding behind Evelyn for PROTECTION*
 & places a glow over the cricket
EVELYN remains calm. She lays her hand across his temples.
The traffic of London murmurs in the background.

 EVELYN
 They're miles away. They don't even
 know you're here.

 EXPLORER
 No, they're coming! They're coming
 to eat us!

 EVELYN
 Nonsense. No one's going to eat us.

The panic passes. The EXPLORER sinks back into the camp bed. *Shot of Lost Expl
with cricket in
glass.*

*a shot from outside
looking backing of laughter
+ ohs & ahs from
Evelyn.*

 EVELYN (CONT'D)
 Rest. Sleep. You're safe now.
 Sleep.

*The Expl'r falls back — admiration
smiling in gratitude + at
Evelyn's control*

POV EVELYN INSIDE TENT LOOKING TOWARDS THE HOUSE.

EVELYN LOOKS AT THE HOUSE THEN LOOKS AT HER WATCH.

*EXPLORER
Whats your name

EVELYN
Evelyn

Explorer*

EVELYN kneels beside him and watches his face with intense
concentration. Then her gaze drifts to the objects on his
camp stool.

*Evelyn, Evelyn,
Evelyn. Give me
your hand —
Youre good!*

On the folding stool beside the camp bed stands an empty
flask, a small oil lamp, a dirty, creased map of the upper
reaches of the Congo, and A revolver with two bullets lying
beside it.

 (CONTINUED)

*Rest sleep -

Evelyn puts her
hand over his
face

Sleep.*

Back in tent:

Evelyn knelt beside him and watched his face with intense concentration for some minutes. Then her gaze drifted to the objects on his camp stool & settled on the black revolver

CONTINUED:

EVELYN reaches out hesitantly, scared yet seduced and clasps the revolver by the grip. It feels cold and heavy. She lifts and presses the barrel to her cheek. She touches it with her tongue, and recoils. She cradles it in her lap, and stares at it. She tries to turn the cylinder, but cannot release it. She eases the safety-catch.

EVELYN screams.

C/U: THE EXPLORER'S SCARRED AND FILTHY HAND HAS CLAMPED ONTO HER OWN, AND HOLDS IT FAST.

The EXPLORER is up on one elbow, staring at her, his harrowed face clenched with anger.

EVELYN gazes at him with wide, shocked eyes.

He takes the revolver from her. Instinctively, she scoops up the two bullets.

 EXPLORER
 And the bullets!

There is a pause, before EVELYN hands them over. Shakily, the EXPLORER loads both chambers.

 EXPLORER (CONT'D) OFFERING EVELYN THE GUN
 shakily —
Conspirators/comrades One for you. One for me. Quick, clearly unable
 in it together sure, painless. Better death. Foil to use the
 the pygmies. Winking. gun.
"Were in this together" — camaraderie. here he
 nods several times as he delivers
He subsides onto his back, suddenly exhausted. His fingers, the dialogue
clutching the revolver, twitch on the sweat stained canvas.
His eyes bulge, Staring then fix upon a point on the roof of the
tent. His whole body shivers, and his limp hand flutters like
an injured bird. ▶ CRICKET ◀ same wavelength.
EXPLORER "YOU'RE GOOD" RECOGNITION.
EVELYN opens her mouth to speak, but the EXPLORER interrupts
her....

 EXPLORER (CONT'D)
 Africa. We'd make two trips a THIS SCENE
The L.E. gestures the year, to the west coast, to collect IS GETTING
birds with his hands. the canaries you understand. → TWILIGHT
smiling. Thousands of them....Way back out
roaming — bird shadows in the middle of the sea, we'd open
and shapes their cages. We'd release them!
 They fly all around the ship in
 great swarms. Great yellow swarms.
 Perching on the masts, swooping
 around the deck...

EVELYN is entranced by this thought. SHE STRIKES A MATCH AND
LIGHTS THE GAS LAMP. MOTHS . ✷ ✷
 ✷ ✷
 ✷ The last Explorer brushes away ✷
 10's of fluttering moths gathered to
 the flame
 (CONTINUED)

> EVELYN

Just wild, you mean? Don't they fly
away? *EVELYN HANGS THE LAMP IN THE TENT*

CONT ...

> EXPLORER

Where can they fly to? There is no
land ~~their little wings~~ ^they^ can reach. ✓ *no - I like
their little
wings.*
They come back to roost ~~once~~ *in the ship.*
they've stretched their wings.

His head lolls.

> EXPLORER (CONT'D)

The yellow clouds of the canary
catchers

THE EXPLORER FALLS ASLEEP.

EVELYN looks at the loaded revolver. She tries to slip it
from his hand, but the fingers tighten on it. It is no use.

Evelyn looks to the house. We see her POV of the house at
dusk.

*"EVELYN"
"EVELYN" Someone calling.*

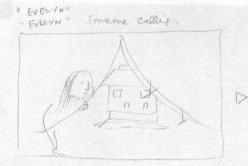

OWL HOOTING

Dark Blue

Lamp

INT. DINING ROOM. NIGHT.

✱ if this whole scene is in real time the timing is wrong ✱

A coal fire crackles in the grate WE PAN UP.

*From here
onwards Evelyn
wants out of
this scene -
She needs to
gather info from
the adults then
she's off.*

Above the mantelpiece hangs a mirror. Invitations to social
functions at the local hospital are tucked into the frame. We
see EVELYN's face reflected in the glass, and then she turns.
Evelyn is dressed in the blue velvet dress with Peter pan
collar.

The PIKER-SMITHS, the CLEGHORNS and EVELYN are seated at
dinner, a sudden gust rattles the window pane.

> ELISABETH PIKER-SMITH

"Are you sure it wasn't
~~Too rare?~~ *Gerald "*

GERALD PIKER-SMITH, a pompous surgeon in his 50s, tentatively
slices a small section of beef and raises the fork to his
lips. He chews the meat thoughtfully. Finally he swallows and
dabs at his lips with a white napkin.

> GERALD

~~Cooked to perfection!~~ ~~so well, I'd like some more darling~~
" Cooked to perfection! Frank Vera more? I'd like some more darling. "

ELISABETH reveals her relief with a smile.
VERA : Yes Mum : all new .
Next to EVELYN at the dining-room table sits VERA CLEGHORN,
AUNTIE VERA, she is a dark haired woman with good teeth. She
wears heavy lipstick. An air of naughtiness hovers over
Auntie Vera.

ELISABETH reveals her relief with a smile& gets up & goes into kitchen.

Next to EVELYN at the dining-room table sits VERA CLEGHORN,
AUNTIE VERA, she is a dark haired woman with good teeth. She
wears heavy lipstick. An air of naughtiness hovers over
Auntie Vera.

 EVELYN *
 Daddy, how do you know if you've *
 got malaria? *

 GERALD *
 Malaria! Good grief...well; the *
 shivers, the sweats, worst case *
 coma and death...you can't catch it *
 here though Evelyn, only in the *
 tropics. *

 EVELYN *
 How do you cure it?

 GERALD On the move to decaster.
 Depends which strain and how deep ▷ *
 the parasite has got into you. Why *
 do you ask? *

 EVELYN *
 School, we are learning about the *
 Congo. *

 GERALD *
 It's not called Congo anymore, it's *
 Zaire now the Belgians have left...ELISABETH ?
 EVELYN
 Do you know anything about Africa
 Auntie Vera?

 VERA Elisabeth
 Africa? Gracious. Well, Frank took eyes raised
 me to Cairo on our honeymoon. He to
 pretended I was Cleopatra! Do you Heaven.
 remember, darling? L explr.
 comes in

 FRANK
 Remember what, sweetheart?

 VERA
 Pretending I was Cleopatra!

 FRANK LOST EXPLR STAGGERS IN.
 Darling how could I forget....?
 (MORE)

EVELYN is sitting opposite Uncle Frank, who has his back to
the open door of the dining-room. Her eyes suddenly widen in
panic.

REVERSE to EVELYN's POV. The EXPLORER is pausing in the
doorway as he shuffles towards the stairs. He turns his head
and stares at her. His head hangs weakly on sagging
shoulders; his eyes burn. His clothes look ragged and filthy
against the flowered wallpaper of the hallway. His scarred,
grimy hands twitch convulsively. He raises his gun.

 Could he be about to shoot the
 dinner party?

 (CONTINUED)

CONTINUED: (2)

UNCLE FRANK, still chuckling at his wifes theatricality, is
flattered at the raptness of EVELYN's apparent attention. It
is only after some moments that he realises her eyes are
trained beyond; and he begins to turn in his seat.

REVERSE to FRANK's POV. In that instant, the EXPLORER — point gun @
shuffles towards the stairs, so that — We see him go past in evelyn etc
EVELYN'S POV. WINK?
 TILLY HO
FRANK, seeing nothing, turns back.

EVELYN gets up and puts down her napkin.

 EVELYN
 Can I go upstairs now? Biology
 homework!

 ELISABETH PIKER-SMITH
 Yes darling, up you go.

 GERALD
 Biology homework. Kiss Auntie Vera
 good night.

EVELYN peremptorily kisses ELISABETH, GERALD & VERA and
shakes hands with FRANK.

 GERALD (CONT'D)
 Good night darling. Well done.

EVELYN hurries out of the room.

INT. EVELYN'S BEDROOM. NIGHT. Scene 10

EVELYN opens her bedroom door in trepidation, and seeing what
is in there, enters quickly and closes the door behind her.
EVELYN'S POV. The Explorer's bush jacket lies discarded on
the floor. The explorer is peeling his crumpled and stained
shirt off. His skeletal body, blue white and boney, rattles
in a baggy vest. The fragility of his naked, ill body forces
EVELYN to look away. THE EXPLORER clambers into EVELYN'S bed
and pulls the sheets up to his chin. His teeth are chattering
loudly and his whole body shivers.

The Last Expl already in bed.

 EXPLORER *he says*
 Cold COLD! *again only louder!*

EVELYN'S concern at his deterioration and her lack of control
is obvious in her expression. She moves quickly to the bed.
She reaches beneath the sheets for his wrist.

She tends to him busily struggling to regain control of the
situation.

 EVELYN
 Here, I need to take your pulse.

Directors note: Love the relationship/friendship between girl and L. Explr. (CONTINUED)
A little shocking

CONTINUED:

She check's her watch. Her expression alters as she feels,
and then slyly withdraws from under the sheet the revolver.

 EXPLORER
 (Shouting)
 Needs will!

In alarm EVELYN slams her hand sharply over his mouth.

 EVELYN
 Sssh! You mustn't talk. *She strokes his hair*

THE EXPLORER tries to continue to talk, muffled. He gestures
towards the bedroom door. He calms down and grows weaker and
his head lolls. He is clearly dying.

His chest heaves with the pain of talking. Let go. EVELYN is
determined to keep him alive. *Coaxing him to life from BRINK OF DEATH*
 Denying the GHOST!
 EXPLORER
 Coming to eat us. Need will do it.
 Pygmies. One for you. One for me. *♫ SOUND OF ADVANCING PYGMY ♫*
 BLOW DART) - & tribal call
EVELYN acutely aware of the EXPLORER'S steady weakening
strokes his chilly brow *AND PLUCKS A POISON DART FROM HIS NECK*
 unflinchingly / unfalteringly SHE IS DEFIANT
 EVELYN
 Don't talk. You're not going to be
 eaten. I won't let them. *Wobbles a bit / sniffles as she looks on*
 adoringly
THE EXPLORER gives up, asleep or unconscious, she searches
THE EXPLORER for a pulse again, she puts her ear to his mouth
to test for him breathing.

 ELISABETH PIKER-SMITH
 (Off screen)
 Evelyn? Can I come and say good
 night?

EVELYN looks at the door handle in horror. Scared and
frightened she contemplates calling out. ✳ *DOES ELISABETH P/S*
 SHOT OUTSIDE DOOR ✳
C/U door handle. It begins to turn.

 GERALD
 (Off screen)
 Elisabeth?

 ELISABETH PIKER-SMITH
 (Off screen)
 SSSSH! What is it?

 GERALD
 (Off screen) *mustard.*
 Where's the toothpaste? *Gravy*
 cigarettes
Smoke comes out of the oven *brandy bottle.* (CONTINUED)

POISON DART

CONTINUED:

> ELISABETH PIKER-SMITH
> (Off screen)
> There's a new tube. In the
> cupboard, 2nd shelf.
>
> GERALD
> (Off screen)
> No, it's not there.
>
> ELISABETH PIKER-SMITH
> (Off screen)
> Oh, Gerald! All right, I'm coming.

The door handle returns to its original position.

EVELYN looks at THE EXPLORER and she picks up a handheld
mirror from her bedside table and holds it to THE EXPLORERS
mouth, on inspection of the mirror the condensation indicates
he's still breathing. She climbs into a make shift bed she
has prepared at the bottom of her own, and lies down with a
deep sigh of relief.

C/U ON EVELYN AS SHE FALLS ASLEEP.

EXT. HAMMERWOOD HOUSE. DAY. DREAM SEQUENCE *Scene (11)*

She and THE EXPLORER are approaching, through the run-down
park, this enormous and dilapidated Georgian mansion. The
misty, orange, light suggests early morning, dawn, or some
magical hour out of time. The Explorer holds a key in his
hand. He leads her up the portico steps smiling and unlocks
the door which gives straight into the crumbling ballroom.
Around it flutters a swarm of canaries, cheeping shrilly,
roosting within the magical rigging.

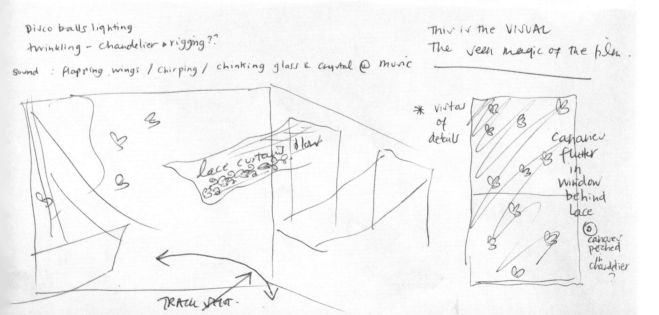

INT. EVELYN'S BEDROOM. MORNING.

EVELYN opens her eyes. She remembers, and sits upright, and looks over to the bed.

THE EXPLORER is lying there still, pale and stiff, and clearly dead.

EVELYN closes his eyes, and then clambers on to the bed beside him. She begins to weep quietly.

✻ Evelyn wept for 10 minutes. She wept into her blankets as the fact of the loss of that long suffering man rose starkly in her heart. And she wept for herself too. Her sorrow was keen ... but it would not fester.
Wet eyed she pulled herself together. EVER PRACTICAL what to do.

INT. LANDING OUTSIDE EVELYN'S BEDROOM. MORNING.

Carrying a cup of tea, ELISABETH, dressed in smart separates, her hair immaculate, walks briskly towards EVELYN's bedroom door, and without knocking, walks in.

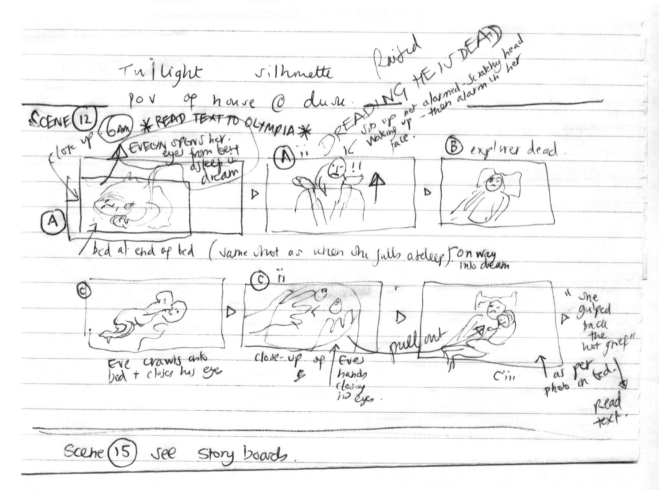

Scene (15) see story boards.

INT. EVELYN'S BEDROOM. MORNING.
The windows are wide open and the day is very blustery
indeed. The curtains flap wildly.

Scene (14)

 ELISABETH PIKER-SMITH
 Really, darling, you'll catch your
 death!'

She goes to the window and closes it, picking her way over
the abandoned hockey paraphernalia.

EVELYN, in the bed, pretends to wake up slowly. There is no
sign of the EXPLORER.

 ELISABETH PIKER-SMITH (CONT'D)
 What's that funny smell? Take your
 hockey things downstairs and
 they'll be clean for when you go
 back to school. It's eight-thirty,
 darling. Daddy's already left for
 work, and I'm off into London. Are
 you going to be alright on your
 own?

 EVELYN
 I'll be fine.

She puts down the tea, kisses EVELYN smartly, and goes out.

INT. EVELYN'S BEDROOM, LANDING AND STAIRS. DAY.

Scene (15)

EVELYN hauls the body of the EXPLORER out of the wardrobe and
drags him downstairs.(Her legs strong from hockey) She moves
slowly, backwards, clutching him by the armpits. His head
lolls about on his chest and his feet bump limply on the
stairs. Bump. Bump. Bump.

INT. KITCHEN. DAY

Scene (16)

EVELYN drags the EXPLORER across the linoleum floor.

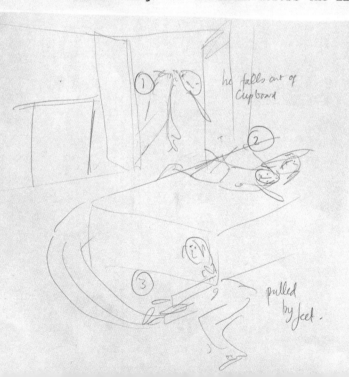

he falls out of
Cupboard

pulled
by feet.

EXT. GARDEN. DAY

The washing-line is alive in the wind with her parent's
underwear. EVELYN manhandles the EXPLORER down the steps.

Outside the garden shed, she lays the body of the EXPLORER
down and pushes open the door of the shed.

She emerges with a shovel.

EXT. GARDEN. DAY

EVELYN digs, her young limbs strong from sport. She has made
a hole in the centre of the clearing in the midst of the most
over grown aspect of the garden.

She collapses the filthy tent, noticing as she does a
multitude of tiny equatorial insects clustering in the seams
and corners.

She drops the tent in the corner of the clearing. & lays at
top the explor

She collapses his camp bed.

She adds the camp stool and its few pitiful possessions.

She lines the hole with the ~~tent~~. Mosquito net

She burns the map of the Congo, using the old vestas, and
blows the ashes into the pit.

She hauls the gun from the EXPLORER's waistband and throws it
in with a sob.

She throws in the flask and the oil lamp. The flames flare
up. Smoke starts to billow and to make her cough.

Finally, she tips in the body of the EXPLORER. The pyre is
burning merrily now, and the smoke, caught by the overgrown
bushes, is becoming impenetrable.

CLOSE in on EVELYN's eyes, streaming with tears.

EXT. BOTTOM OF GARDEN BY FIRE. DAY

EVELYN emerges through the smoke of the fire and her dreams
still sobbing.

She continues through the smoke and slowly walks up to the
house and her impending adulthood.

FADE TO BLACK.

The smoke fills the frame
a page turns. (Burnt pages)...
page flutter past & the book shuts.

THE END

IMPRINT

© 2011 teNeues Verlag GmbH + Co. KG, Kempen
Photographs © 2011 Tim Walker. All rights reserved.
Photographs endpapers © Royal Geographical Society (with IBG)

The Lost Explorer © 2011 Patrick McGrath. All rights reserved.
First published in: Patrick McGrath, Blood and Water and other Tales, Poseidon Press 1988

Book design by Shona Heath & Neil Emery

Editorial coordination by Arndt Jasper, teNeues Verlag
Production by Nele Jansen, teNeues Verlag
Color separation by ORT Medienverbund, Krefeld

Published by teNeues Publishing Group

teNeues Verlag GmbH + Co. KG
Am Selder 37, 47906 Kempen, Germany
Phone: +49-2152-916-0
Fax: +49-2152-916-111
e-mail: books@teneues.de

Press department: Andrea Rehn
Phone: +49-2152-916-202
e-mail: arehn@teneues.de

teNeues Publishing Company
7 West 18th Street, New York, NY 10011, USA
Phone: +1-212-627-9090
Fax: +1-212-627-9511

teNeues Publishing UK Ltd
21 Marlowe Court, Lymer Avenue, London SE19 1LP, Great Britain
Phone: +44-208-670-7522
Fax: +44-208-670-7523

teNeues France S.A.R.L.
39, rue des Billets, 18250 Henrichemont, France
Phone: +33-2-4826-9348
Fax: +33-1-7072-3482

www.teneues.com

ISBN 978-3-8327-9446-0

Printed in Italy

Bibliographic information published by the Deutsche Nationalbibliothek.
The Deutsche Nationalbibliothek lists this publication in the Deutsche Nationalbibliografie;
detailed bibliographic data are available in the Internet at http://dnb.d-nb.de.

MIX
Paper from responsible sources
Papier aus verantwortungsvollen Quellen
FSC® C006866

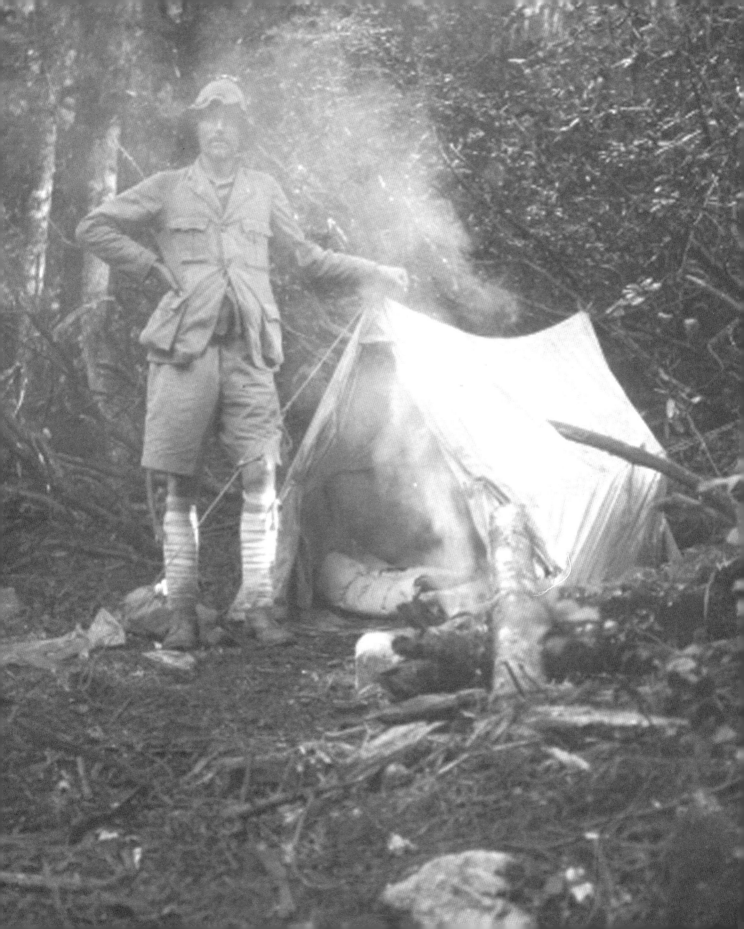

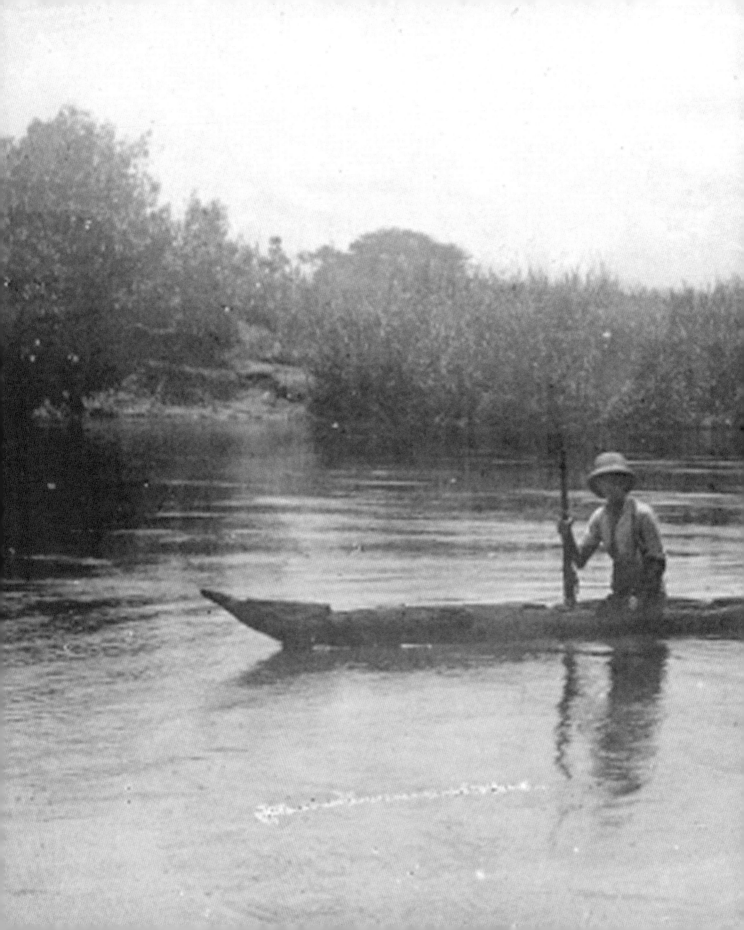